COLORWAYS

ACRYLIC ANIMALS

TIPS, TECHNIQUES, AND STEP-BY-STEP LESSONS FOR LEARNING TO PAINT WHIMSICAL ARTWORK IN VIBRANT ACRYLIC

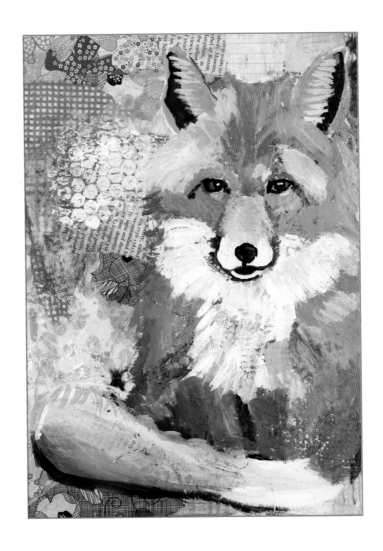

MEGAN WELLS

Brimming with creative inspiration, how-to projects, and useful information to enrich your everyday life, Quarto Knows is a favorite destination for those pursuing their interests and passions. Visit our site and dig deeper with our books into your area of interest: Quarto Creates, Quarto Cooks, Quarto Homes, Quarto Lives, Quarto Drives, Quarto Explores, Quarto Gifts, or Quarto Kids.

First published in 2019 by Walter Foster Publishing, an imprint of The Quarto Group.
26391 Crown Valley Parkway, Suite 220, Mission Viejo, CA 92691, USA.
T (949) 380-7510 **F** (949) 380-7575 **www.QuartoKnows.com**

Walter Foster Publishing titles are also available at discount for retail, wholesale, promotional, and bulk purchase. For details, contact the Special Sales Manager by email at specialsales@quarto.com or by mail at The Quarto Group, Attn: Special Sales Manager, 100 Cummings Center, Suite 265D, Beverly, MA 01915, USA.

ISBN: 978-1-63322-614-2

Digital edition published in 2019
eISBN: 978-1-63322-615-9

Page layout: Melissa Gerber

Printed in China
10 9 8 7 6 5 4 3 2 1

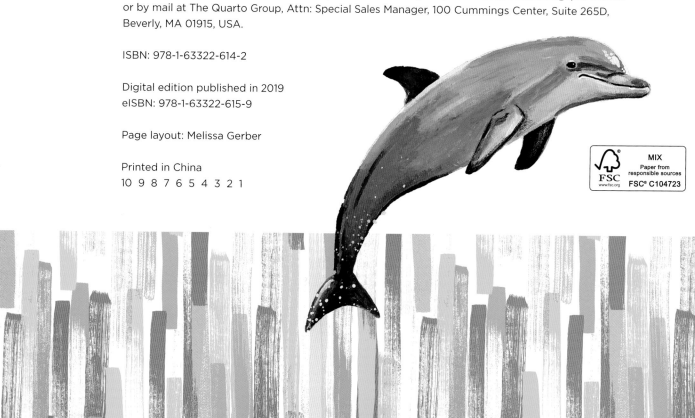

MIX
Paper from responsible sources
FSC® C104723
www.fsc.org

TABLE of CONTENTS

Introduction

Animals are one of my favorite subjects to paint. Each creature has its own unique qualities: interesting shapes, feathers or fur, distinctive markings, and of course, various colors. With so many species and subspecies of animals, the well of inspiration never runs dry. And just as I enjoy painting animals, I love color…bold, expressive color that makes you look twice.

In *Colorways: Acrylic Animals*, you'll find a variety of projects and easy-to-follow, step-by-step instructions covering a range of animals and color schemes. As you work through each project, I encourage you to focus on using color in expressive and whimsical ways instead of trying to capture a realistic image of each animal. There are no restrictions with color. As you work through each exercise, let go of any fear and just go for it!

At the beginning of this book, you'll find helpful tips on sketching your subject matter, acrylic painting tools and techniques, and the basics of mixing color and color theory. We'll talk about the importance of value and contrast, as well as using the intensity of each color to add depth and dimension.

The projects include gorgeous visual references, plus tips and tricks to use along the way. Feel free to use my sketches as the guidelines for your paintings, or create your own visual references from which to work. If you are not confident in your drawing skills, don't worry; I'll give you some helpful tips in "Getting Started" (see page 19).

Most of all, I hope you enjoy the process of creating and find yourself lost in a sea of color!

Tools & Materials

Let's begin by talking about what you'll need to complete the projects in this book—starting with, of course, paint!

ACRYLIC PAINT

Acrylic paint can range from inexpensive to break-the-bank pricey. Student-grade acrylics are more affordable, but they provide less coverage than professional-grade paints. I have found, unfortunately, that the more expensive a paint is, the better it performs. However, I always recommend starting with cheaper student-grade paints and working your way up to costlier professional-grade ones as your skills improve.

Acrylic paint also varies according to viscosity, or consistency. For instance, heavy-bodied paint is thicker and great for adding texture, while high-flow paint works well for details and line work.

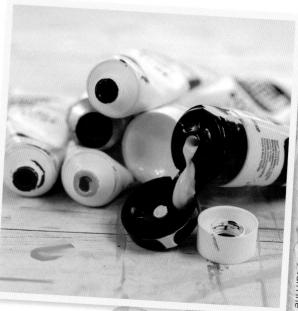

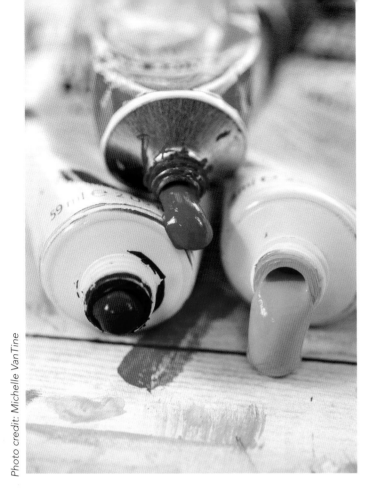

PAINT COLORS

There are so many colors of acrylic paint to choose from! To simplify your shopping process, I've narrowed down your list to just 9 tubes of paint. With these 9 tubes, you can paint your way through the rainbow. Yes, you really *can* mix almost every color there is with these 9 tubes!

9 Essential Colors

Titanium white
Black
Ultramarine blue
Phthalocyanine blue
Cadmium red
Quinacridone magenta
Cadmium yellow
Hansa yellow
Burnt umber

BRUSHES

For brushes, I recommend keeping it simple and selecting a few sizes of round brushes and a few sizes of flat brushes. I prefer synthetic bristles over natural ones, but I recommend trying both to see what you like best!

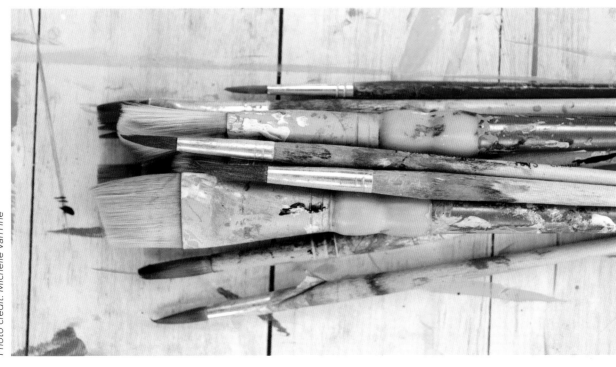

PALETTE

A palette can be just about anything you have that's flat. If you choose to buy a palette, it can be made from plastic or porcelain. I tend to use a paper plate or some wax paper!

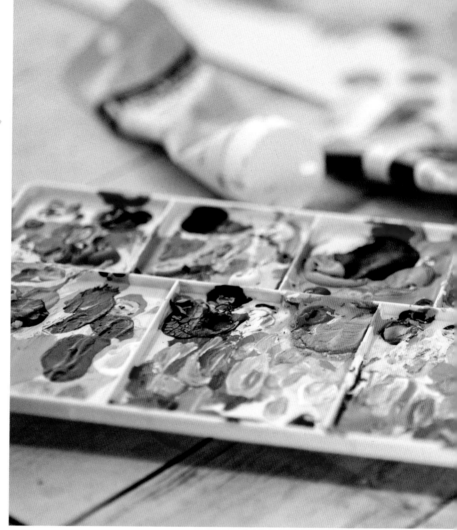

Photo credit: Michelle VanTine

PAINTING SURFACES

When working with acrylic, you can paint on just about any surface! To create the projects in this book, I worked on three different surfaces.

CANVAS: This is considered the standard painting surface. You can buy pre-stretched canvases at any art-supply store.

BRISTOL BOARD: This is unfinished paper board, and it's great for many kinds of supplies. I often work on Bristol board when I'm painting smaller pieces, as it's easy to store and scan into the computer for reproduction, and it's versatile. It's also easier to frame than a stretched canvas. Unlike canvas, however, Bristol board will bow if saturated with too much water.

WATERCOLOR PAPER: Just because it's called "watercolor" doesn't mean it can only be used for watercolor paints! This type of paper comes either cold-pressed (textured) or hot-pressed (smooth). It's your preference! Try them both and see which you prefer.

PENCILS

You'll need a good-quality pencil for sketching. Drawing pencils range from very hard lead (labeled 9H) to very soft lead (9B). The harder the lead, the lighter your pencil will draw. When sketching your subject matter before painting, it's best to draw lightly, so use harder lead.

MATTE GEL MEDIUM

Gel medium is very adhesive and makes a wonderful tool for collaging. It's also easy to work with and dries clear, so you can mix it with your acrylic paint to create transparent colors and even out texture.

MODELING PASTE

An acrylic medium that's filled with a solid material, modeling paste dries opaque white and can be used to add texture to artwork. Spread it on your canvas and paint over it once dry, or mix it with your paint and then apply to the surface. Because it is white, it will lighten the paint color.

PALETTE KNIFE

A palette knife is used for mixing colors. I usually mix colors with a brush, but for creating a large amount of color, a palette knife is a great tool to have on hand. It can also be used to apply paint to your surface, making it a wonderful tool for creating dimensional, textured pieces.

Acrylic Painting Techniques

Painting techniques can be used to create different textures and effects in art. Here are some of my personal favorites.

WASH

Before slapping on thick layers of paint, I like to wash in color over my entire surface. This provides a first layer of paint and helps eliminate any fear of the white paper.

A wash is simply watered-down acrylic paint. To create a wash, mix a tiny bit of paint with a lot of water.

UNDERPAINTING

A wash can serve as an underpainting; however, a traditional underpainting is usually monochromatic (one color with many values) and applied thicker than a wash. The underpainting is the base layer of paint upon which subsequent layers build.

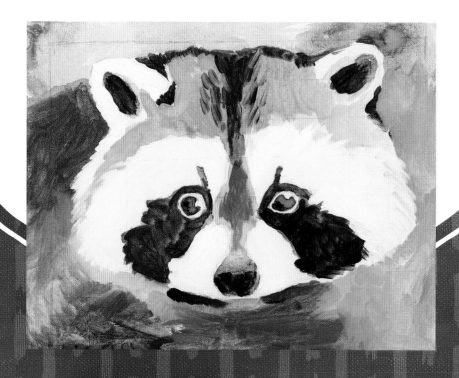

BLOCKING IN COLOR

This simply means painting in large areas of color. When building up a painting, it's best to work from less detailed to more so. Blocked-in color comes after a wash or an underpainting.

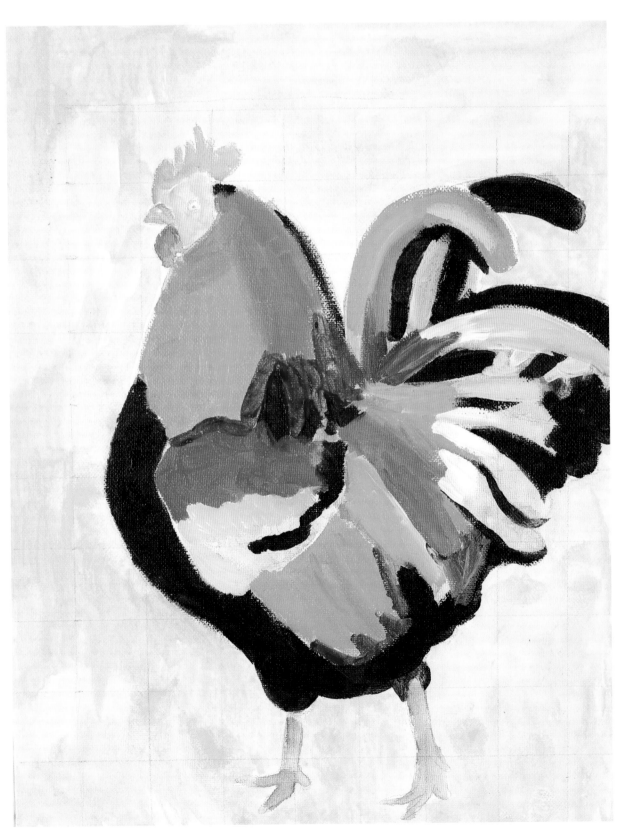

DRYBRUSHING

Add acrylic paint to a surface without first dipping the brush in water. Drybrushed strokes remain visible and have an almost scratchy appearance.

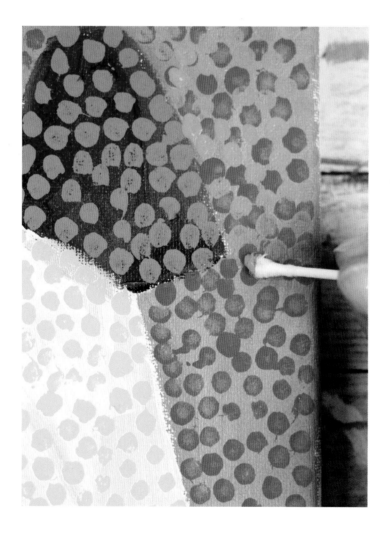

STIPPLING

Small dots or specks of color are layered upon one another.

Georges Seurat (1859-1891), the French post-Impressionist painter known for *A Sunday on La Grande Jatte*, made this technique famous. We will use it to paint "Pointillistic Panda," starting on page 104.

IMPASTO

Paint is applied thickly, resulting in a textured surface.

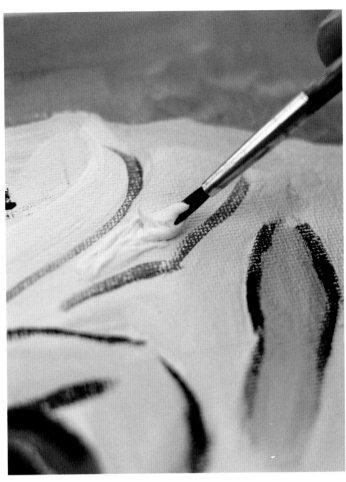

COLLAGING

Various materials, such as fabric and paper, are pasted onto a piece of art, creating an interesting, layered effect.

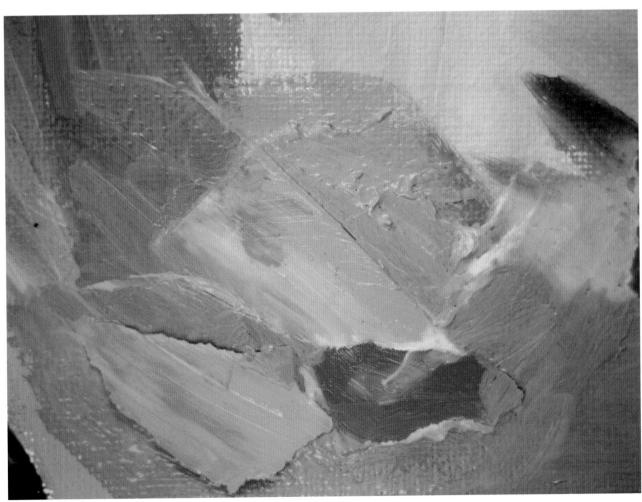

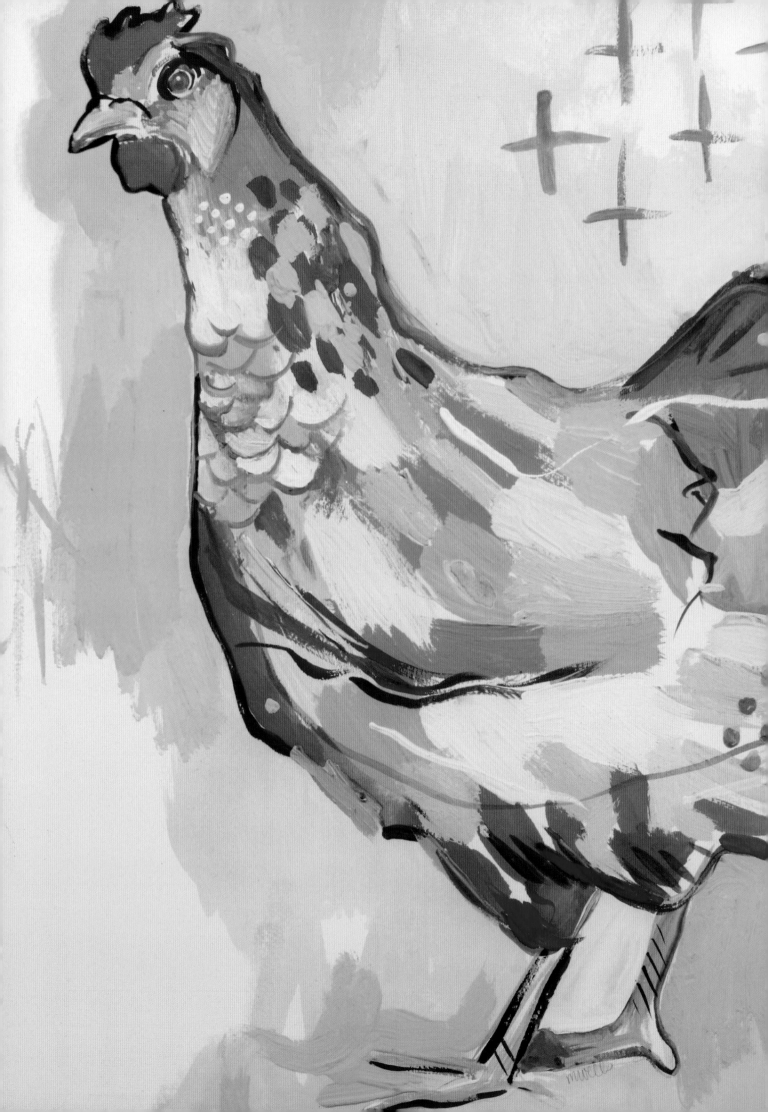

Color Theory Basics

If you wish to express yourself with color in wild, spontaneous ways, there are a few basic principles about color that you should understand.

THE COLOR WHEEL

The color wheel is a tool for organizing colors. It consists of three primary colors (red, blue, and yellow); three secondary colors (orange, green, and violet), which are created by mixing the primaries together; and six tertiary colors (red-orange, yellow-orange, yellow-green, blue-green, blue-violet, and red-violet) that occur from a mixture of a primary and a secondary color.

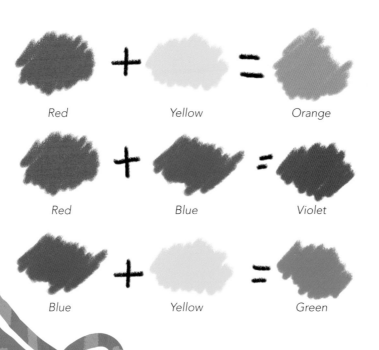

Red	+	Yellow	=	Orange
Red	+	Blue	=	Violet
Blue	+	Yellow	=	Green

HOW TO CREATE SECONDARY COLORS

COLOR CUES

In art, the word "value" refers to how light or dark a color is. To darken the value of a color, you add black to create a shade. To lighten a color, add white to create a tint.

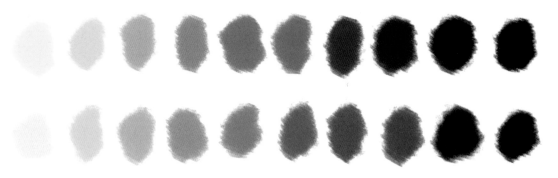

A value scale organizes values. To explore a color's range of value, create your own value scale.

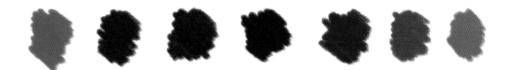

Colors also vary according to intensity, which refers to how dull or bright a color is. To dull a color, add its opposite, also called its "complement." For instance, the opposite of red is green. To dull a shade of red, mix in a bit of green.

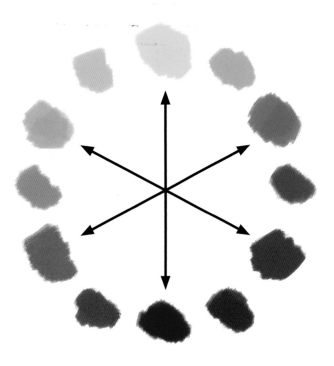

Complementary Colors

Even if you are usually more drawn to bright colors, you shouldn't avoid dull ones. The contrast between dull and bright colors adds depth and dimension to artwork.

The color wheel is also organized by temperature. Green, blue, and violet are considered cool colors. Consider water, the icy blue reflection of snow, a dreamy rainforest—these colors tend to have a calming, peaceful effect. Yellow, orange, and red are warm colors. Think of fire and the sun. These colors give off warmth and energy.

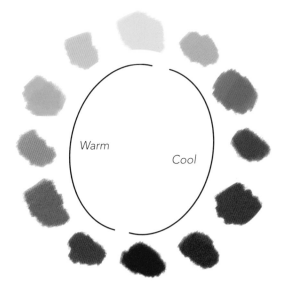

Warm

Cool

Quinacridone Magenta + Ultramarine Blue

Quinacridone Magenta + Phthalo Blue

Cadmium Red + Ultramarine Blue

Mix It Up

The color wheel is just a helpful diagram, not a comprehensive guide for mixing colors.

In theory, red plus blue will equal a perfect violet. As you'll find when working with acrylics, however, there are many blues and reds. And they have names like phthalo blue and alizarin crimson. That can get confusing and overwhelming if you've never shopped for acrylics before.

On page 7, I've listed nine foundational colors that you may want to start with. You can accomplish everything in this book with just the nine colors I've listed, but of course, feel free to add as many paints to your palette as you'd like. The more, the merrier!

Once you have your paints, I recommend trying as many combinations of colors as possible. Make a value scale for each color. You'll find that phthalo blue and ultramarine blue look very different. You'll stumble upon discoveries, like that cadmium red is warmer than alizarin crimson. And, depending on which red or blue you choose, you'll create a different violet with each combination.

You can study color theory as much as you want, but the best way to learn is to get your paints out and experiment!

HEAVY
BODY
ACRYLIC™

TITANIUM WHITE
BLANC DE TITANE
BLANCO DE TITANIO
BIANCO DI TITANIO
TITANWEISS

Lightfastness/Résistance à la lumière/
Solidez a la luz I
Series/Série 1

138 ml ℮ 4.65 US Fl oz

Getting Started

JUST PLAY!

One of the most important lessons I hope to teach you in this book is not how to paint a perfect animal or become an expert on color theory. Instead, I want you to learn to let loose! Let go of working stiffly and don't be afraid to make mistakes. Loosen up and play!

Both color and animals can be playful elements in art: animals in their own cute and furry ways, and color in surprising manners. As we combine these two topics, I hope that your own artistic playfulness will expand as you learn to paint and use color in exciting, unexpected ways.

I spent six years teaching high-school art classes, and I became famous for saying, "All right, let's play!" when my students began working. The idea of approaching my work in a playful way has been with me for some time—probably as long as I've been making art.

But I also believe in establishing artistic boundaries that will push and challenge you. For that reason, we'll work through some color theory basics as we go from project to project, essentially getting more and more playful as the book proceeds. Try to work within the boundaries for each project, and let it inspire you to try color combinations and techniques you may not have thought to use before.

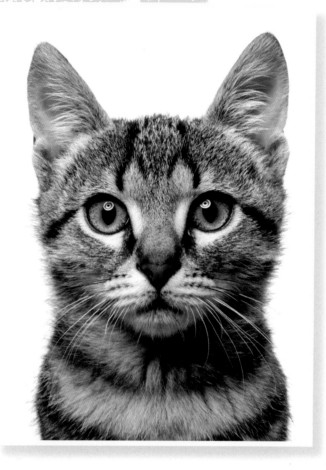

WORKING WITH REFERENCE PHOTOS

I encourage you to source your own images to work from as opposed to trying to emulate my art exactly. My approach to instructing is to instill as much creativity in you as I can. Let my examples inspire you, and avoid the temptation to copy exactly what I've done. For this reason, I've included only basic sketches of each animal with the step-by-step projects. I encourage you to research and discover what inspires you.

Of course, unless you spend lots of time at the zoo, you might not have that many animal images to work from. Now and then I'll take a photo of an animal that I want to paint, but usually that's not the case. Instead, I rely on the internet. My favorite sources for animal photos are royalty-free websites, which provide images that anyone can download and use for free.

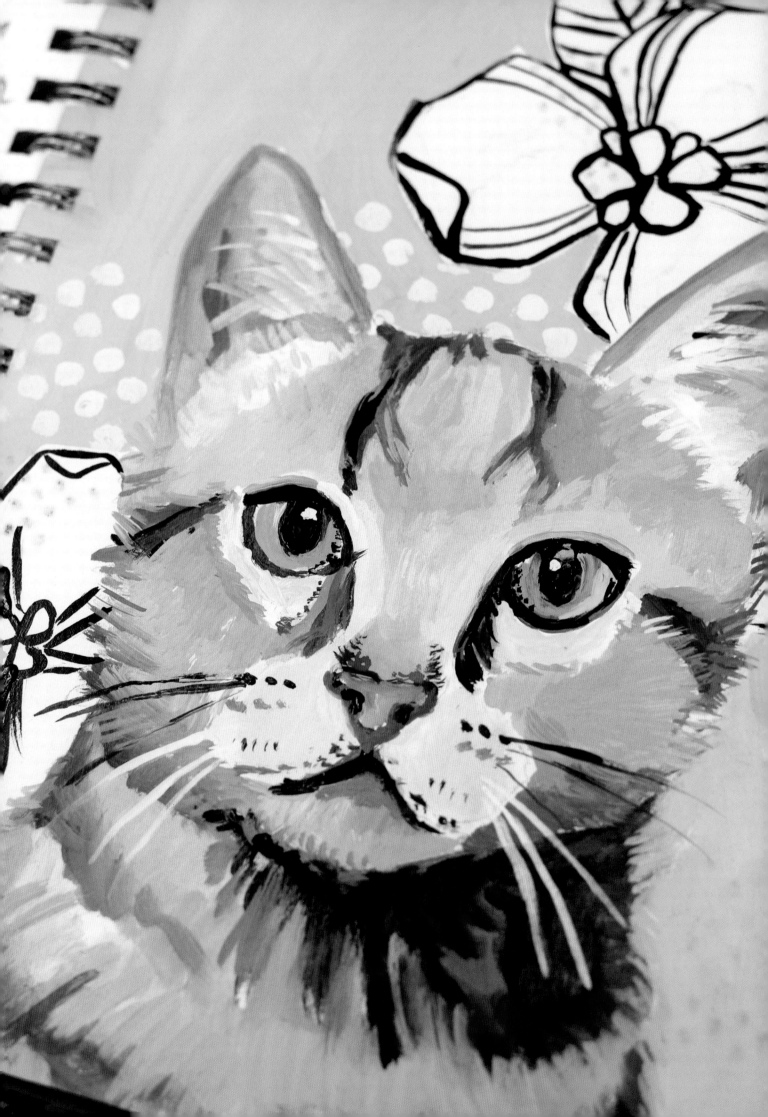

SKETCHING

If you are comfortable with your drawing skills, I encourage you to sketch each animal freehand. Some animals are easier to draw than others. We aren't striving for "perfect" in this book; we want colorful, expressive animals. If your sketch isn't an exact replica of your image, that's OK! Instead, try to capture the essence of the animal in the image you are using.

If you need a little help with your drawing, use transfer paper or a light box to trace your image onto your painting surface. Keep in mind that these tools only work if your painting and your reference photo are the same size.

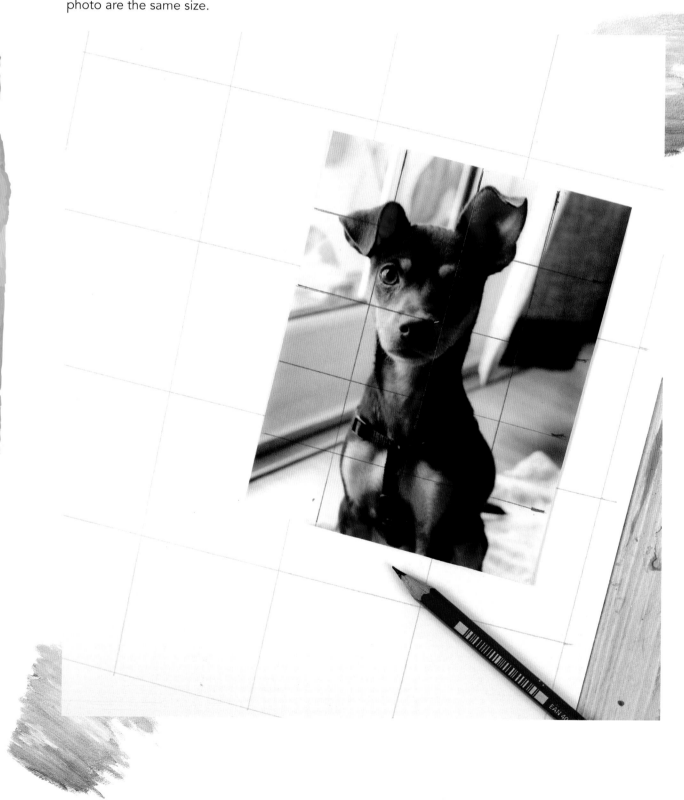

If you aren't confident with sketching freehand and would like to enlarge the image you're working from, you can try the grid method. This is a technology-free, inexpensive way to reproduce and enlarge an image. It involves drawing a grid over a reference photo, and then drawing a grid of the same ratio onto the painting surface. For instance, if your reference image is 4" x 5", draw a grid on top of it that consists of one-inch squares: four across and five down.

If your painting surface is larger, increase the size of your grid while maintaining a 1:1 ratio. For instance, to double the size of your image (8" x 10"), draw a grid made up of two-inch squares—again, four across and five down. To quadruple the size (16" x 20"), draw four-inch squares, and so on.

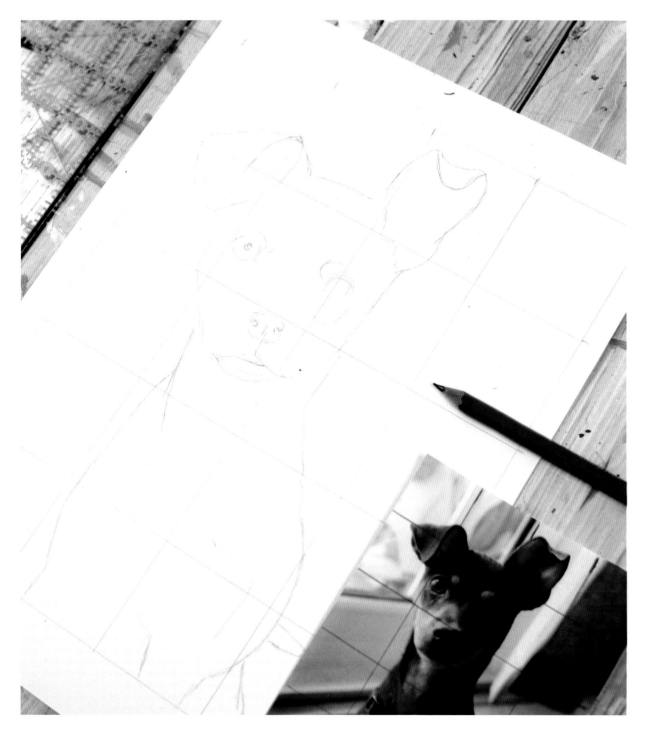

Dividing your main image into smaller sections enables you to see where everything should go.
Work square by square to draw in your animal's main shapes.

ORDER OF OPERATIONS

When painting in acrylic, it's best to work from general to specific. Think of painting as building a house. First, lay the foundation (the wash or underpainting). Next, build the frame of the house (blocking in broad areas of color). Finally, add the drywall, crown molding, and hardwood floors (the details). You wouldn't build a house by constructing one wall at a time, from start to finish. In the same way, avoid painting tiny sections of details in your piece before building up each layer together.

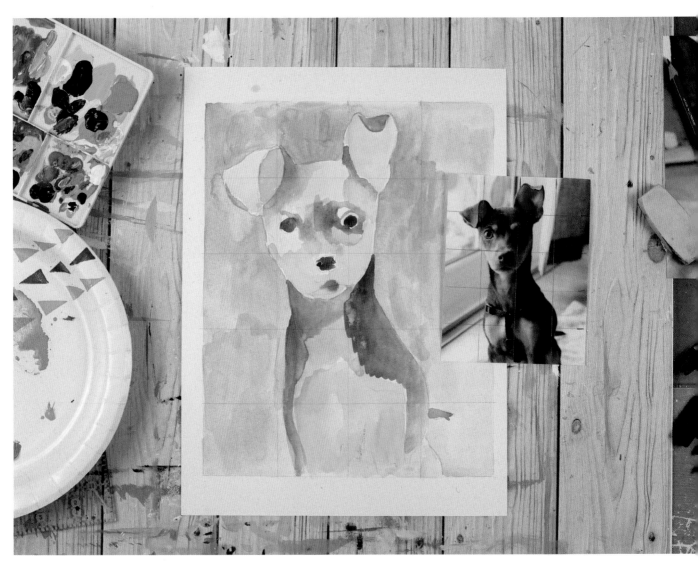

Wash

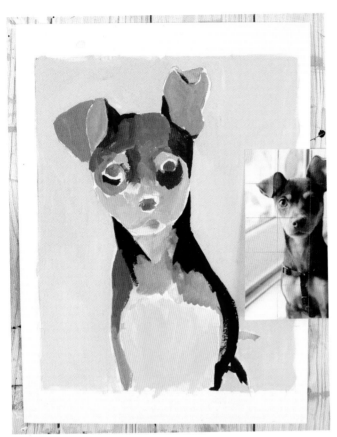

Blocking in

Keep these tips in mind as you work through the projects in this book. And most of all, don't forget to play!

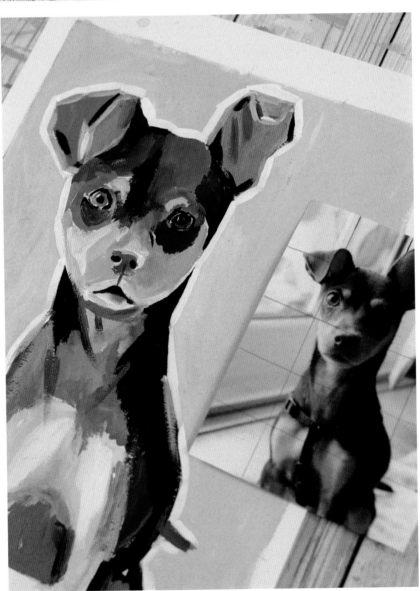

Final image

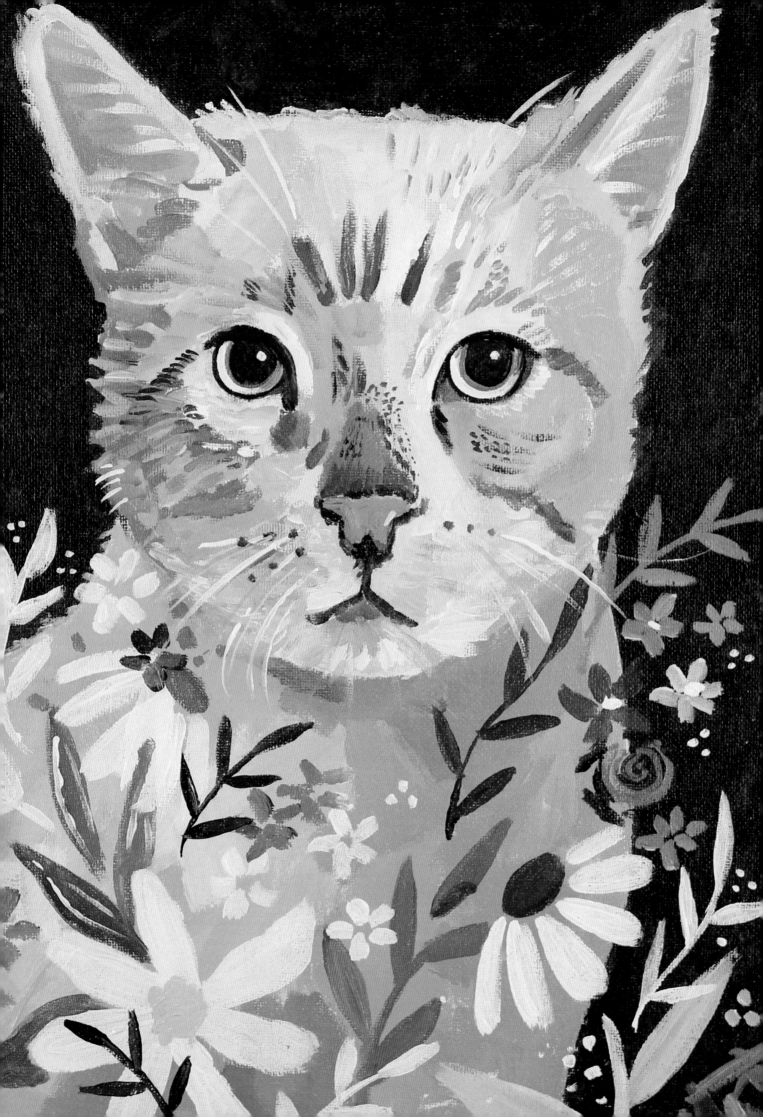

STEP-BY-STEP PAINTING PROJECTS

(Cool) Analogous Dolphin

An analogous color scheme is a great place to start if you're just learning to paint and explore color. It features colors that sit near each other on the color wheel, such as red, orange, and yellow, or blue, violet, and green.

In this project, I've chosen to use cool analogous colors: green, blue-green, blue, blue-violet, and violet. Let's focus on pushing the values of those colors. This means featuring a full range of values, from very light (white or almost white) to dark.

Here you can see my color palette. I've included not only the main hues, but also the full range of values for each. This gives me a clear sense of the colors I can choose from as I work.

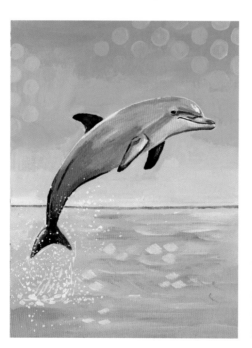 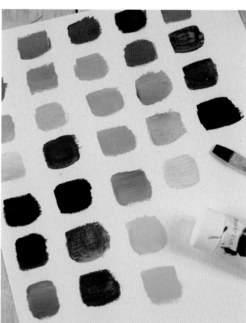

1

Sketch the dolphin freehand, or use the grid method (see page 23) to transfer the animal's main shapes onto your paper. Your sketch doesn't need to be perfect; simply try to capture the dolphin's main features.

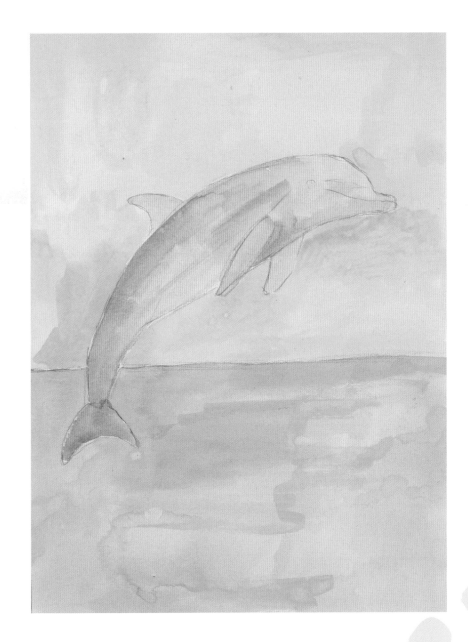

2

Wash in the broad areas of color using a large round or flat brush (whichever you prefer!). Look for the main shapes in your composition, and block in washes of color on the dolphin and in the background.

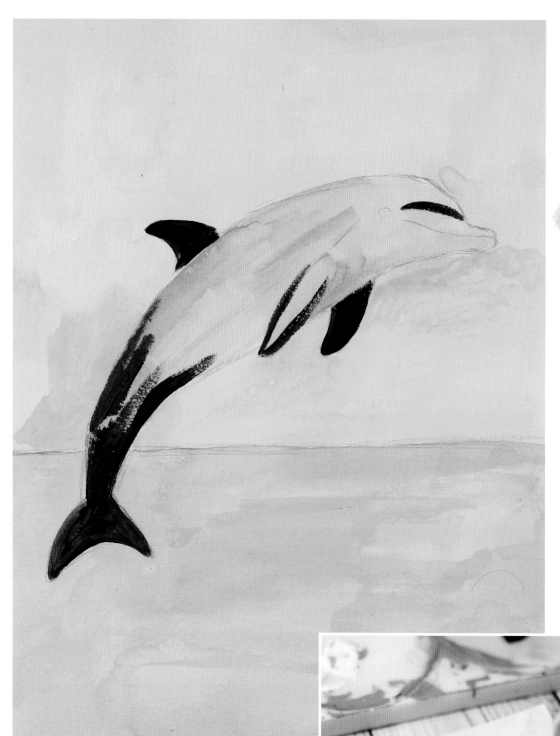

3

Block in broad areas of color over the wash. I recommend starting with the darkest values and working your way from dark to medium to light.

Cover your entire surface (both the dolphin and the background) with paint, without adding details, smooth blends, or opaque blocks of color just yet.

I tend to paint very expressively when blocking in my colors.

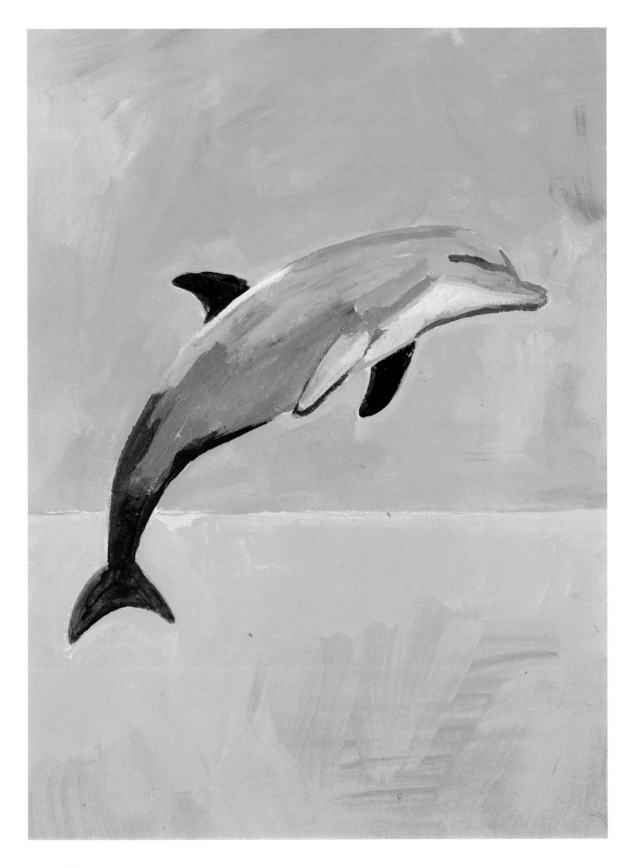

4 Begin building up detail. As mentioned on page 24, it's best to work from general to detailed when painting, as opposed to diving right into the finer details.

I add another layer of paint and then incorporate more colors and values into the piece. I also blend the colors on the dolphin's body.

When blending colors on your surface, work quickly. Acrylic paint dries fast!

5

Paint the background details. You can be as creative as you want with the background. Paint expressively, or try an ombré effect, smoothly transitioning from dark to light.

I leave the horizon line in my piece to add realism and paint the water with horizontal brushstrokes.

The background of your painting is just as important as the foreground.

I fade the sky slightly from a very light green to a medium-valued green.

Now, build up details. This is when you will make your animal stand out, so add as much detail as you want. Look for the little things: the shine on the dolphin's wet skin, the glimmer in its eye, and the slight curve of its mouth.

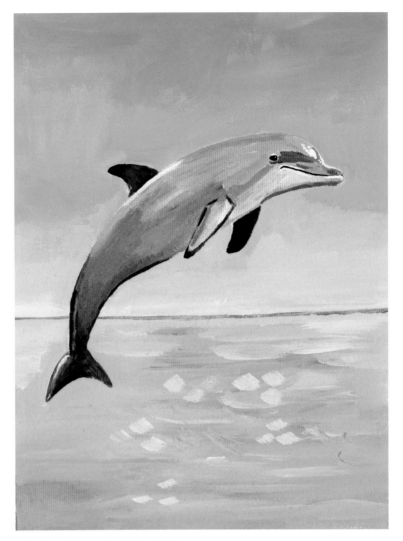

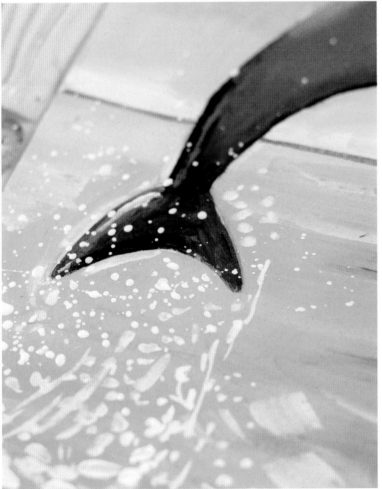

In my reference photo, the dolphin creates a splash as it jumps out of the water. I use the splattering technique to emphasize that effect.

7 Fine-tune your piece. Step back and critique yourself. Do you have a full range of values? Does the dolphin stand out against the background? Is the artwork visually interesting?

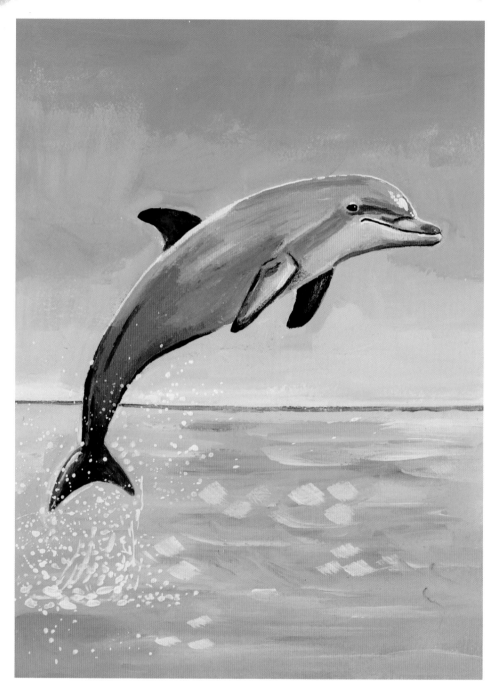

I'm often asked how I know when I'm done with a piece. When you're painting, only you know the answer to that question. Work until you feel it in your gut—every painting is different.

 8 I feel that my background is a little boring, so I add some subtle-but-whimsical polka dots. How fun are they? Then I'm satisfied with my artwork.

Congratulations on completing your first colorful animal! We're just getting started!

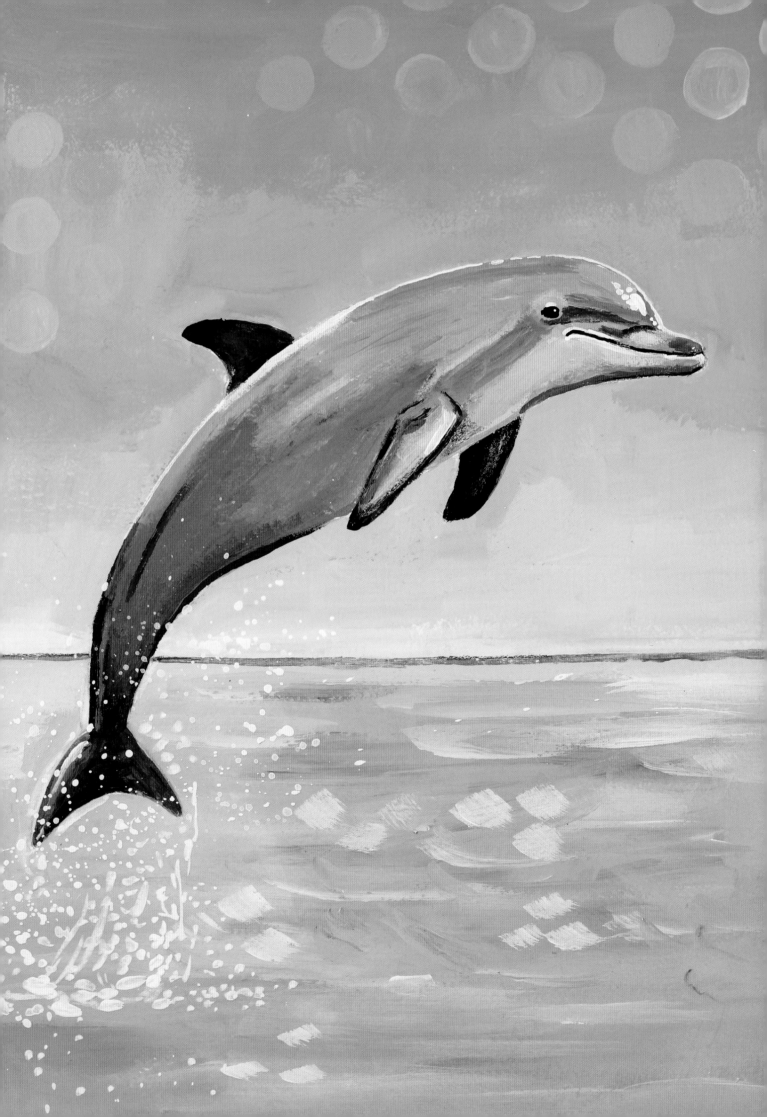

(Warm) Analogous Chicken

This project uses an analogous color scheme as well, but instead of cool colors, let's switch to warm. I chose to work with red, red-orange, orange, yellow-orange, and yellow. And don't forget all the values of those hues!

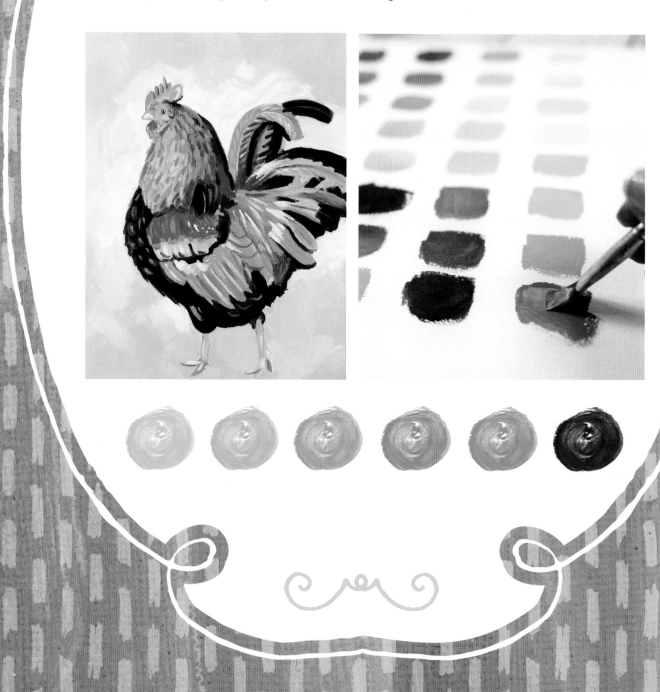

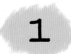

1 The process for this piece is similar to the other projects used in this book. However, for this piece, I work on an 11" x 14" stretched canvas.

First, sketch the rooster. I use the grid method (see page 23) to make an accurate rendering.

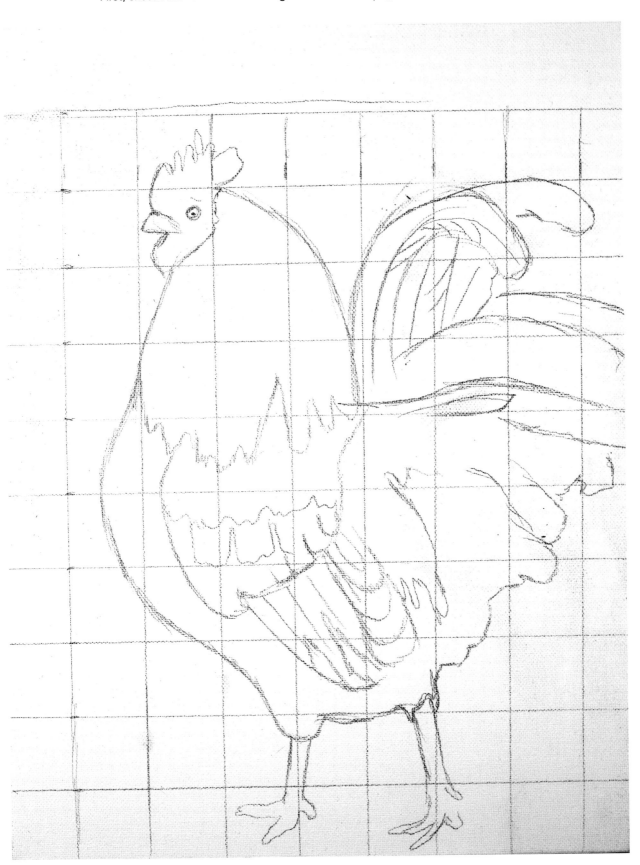

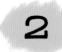

2 Next, wash in the broad areas of color. A wash gives you a good sense of where to place each color, but don't fret over color placement. One of acrylic paint's best qualities is that you can paint over it. Go with your gut (you are going to hear me say that a lot!), and rest assured that you can always change what you don't like.

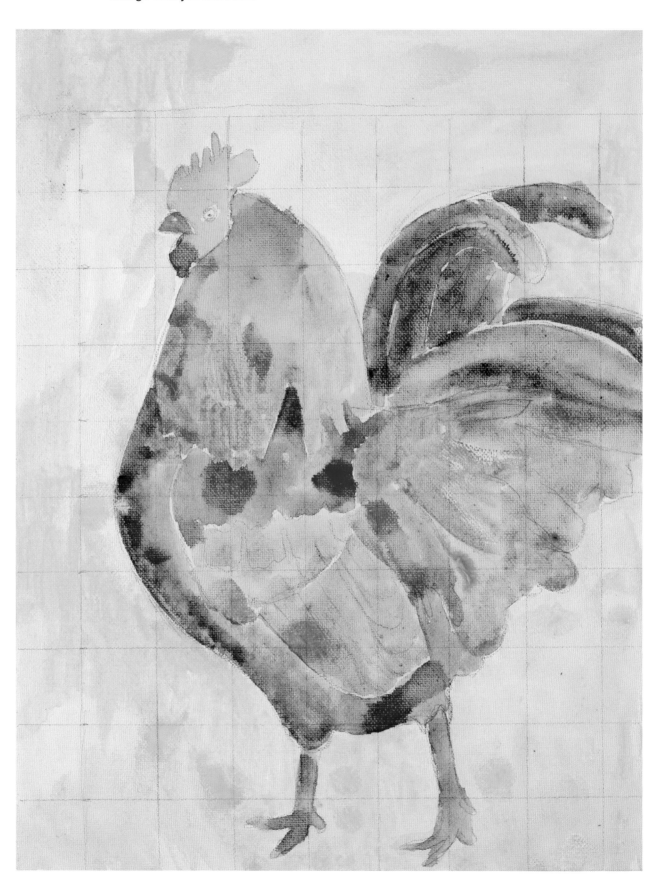

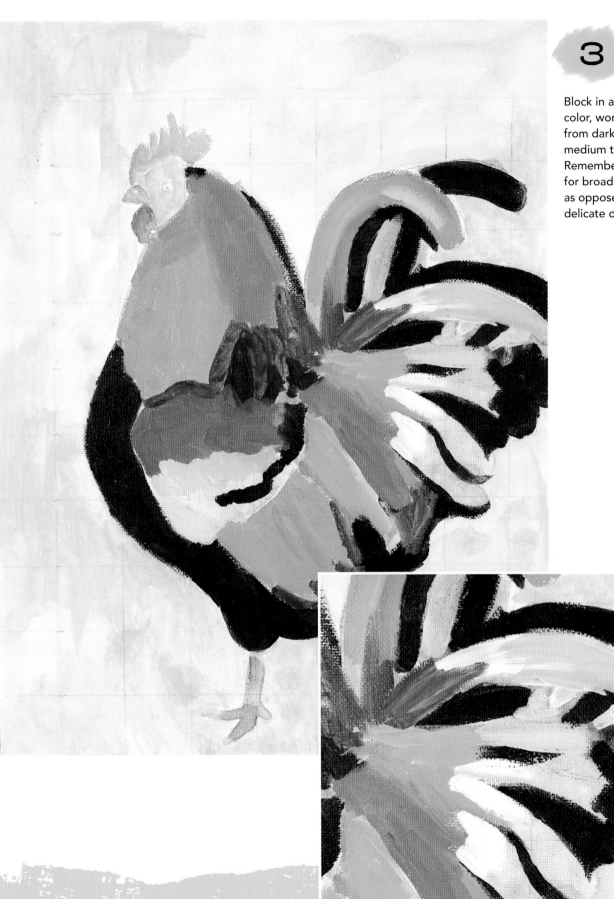

3

Block in areas of color, working from dark to medium to light. Remember to look for broad shapes as opposed to delicate details.

 4 Move to the background. I paint the background yellow, with white and light yellow highlighting the darker chicken. Yellow is a more transparent color, so it takes a few coats to cover the pencil marks.

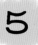

5

I approach the chicken much differently than the dolphin. A chicken features so many fun textures to play with: feathers that go in different directions, various shapes, and so on. Instead of blending colors seamlessly and keeping the painting nice and neat, as I did with the dolphin, I paint the rooster more expressively as I build up the details.

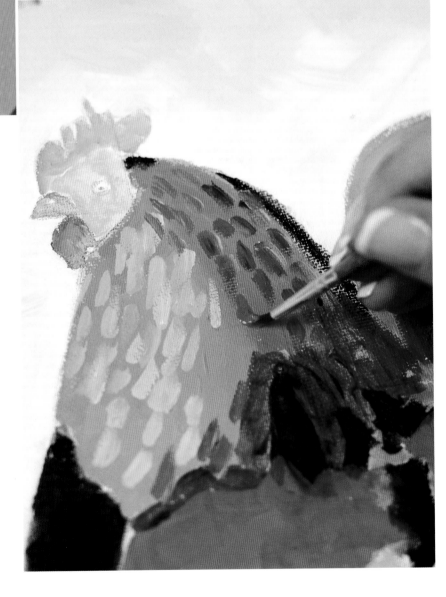

Layer small brushstrokes of color, moving your brush in free and even messy ways.

If you prefer to work on the background after building up your details, go for it! I often change the order of how I do things based on my mood as well as my subject. You can also work on the details and the background simultaneously.

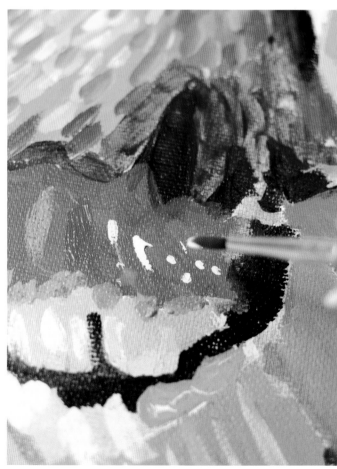

Add the fine details. Decide how detailed you want to get!

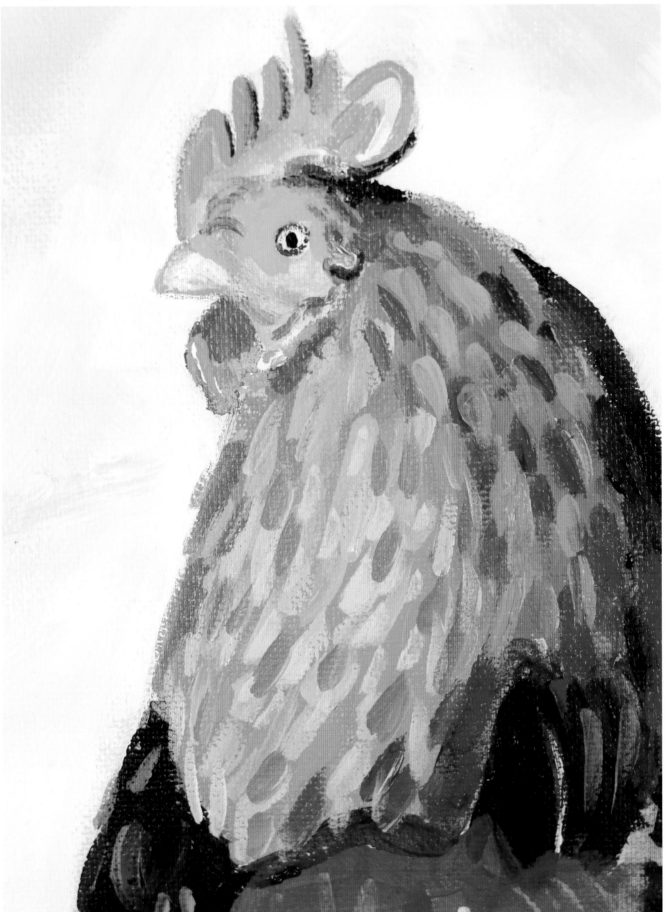

8 I am very specific with the chicken's eye and head, but otherwise I add details by layering more and more expressive strokes of paint.

Details don't have to mean tiny areas done with a tiny brush! Because I worked more expressively here, I added details with layers of broad strokes of paint to finish the piece.

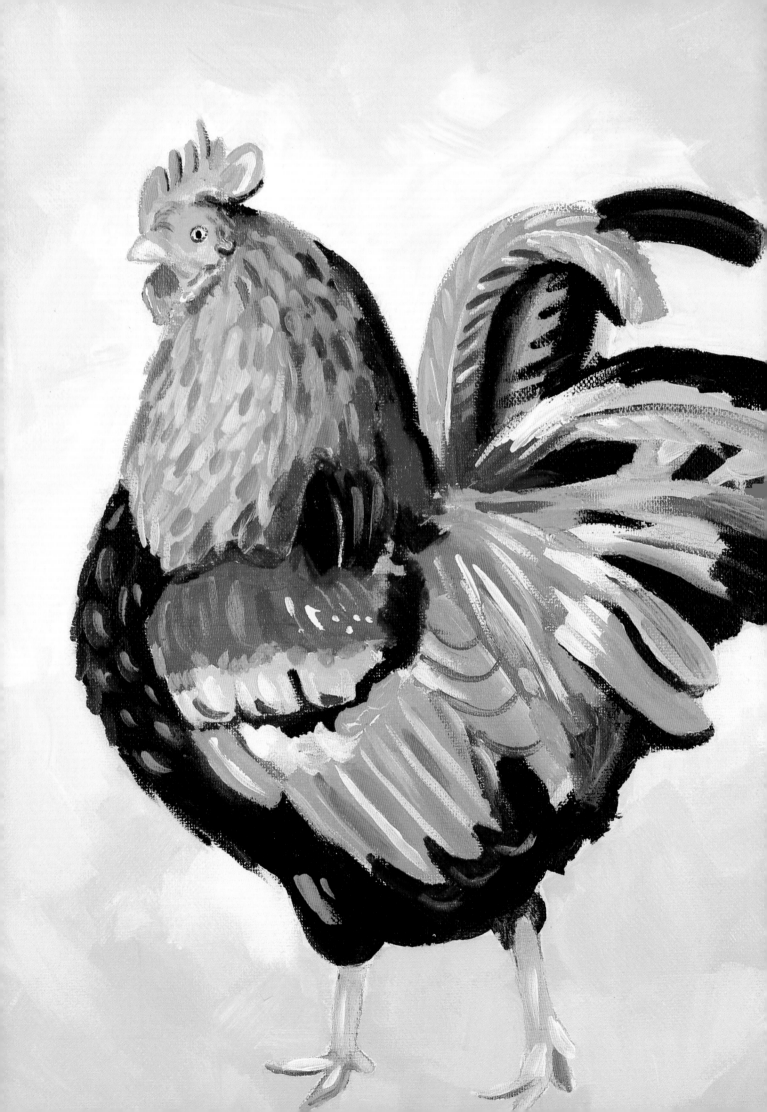

Complementary Cow

A complementary color scheme is one of my favorite ways to make a bold statement. Remember: Complements are colors that sit opposite from each other on the color wheel—for example, red and green, orange and blue, and violet and yellow. Extremely high in contrast, the complementary color scheme grabs the eye and makes an impact.

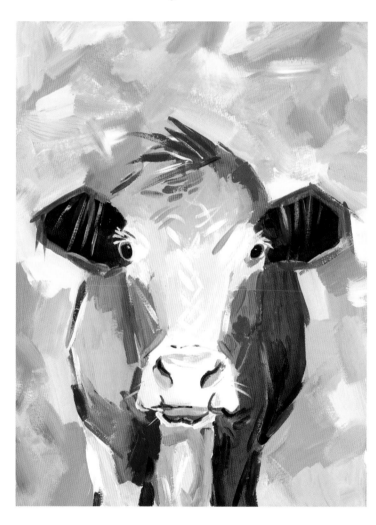

This time, let's look at the intensity of the colors in addition to their values. If you recall, intensity refers to how bright or dull a color is. To change the intensity of a color, add its opposite. You can also change the value of the intensities. Every color you mix features a full range of values, so even though your palette is limited to two colors from the color wheel, the possibilities are still endless!

In this piece, I'd like you to try being even more expressive. Think in terms of broad brushstrokes and expressive mark-making. Don't worry about creating a realistic-looking cow; instead, try to capture the essence of the cow in a colorful, funky way.

Here's the color palette that I worked with:

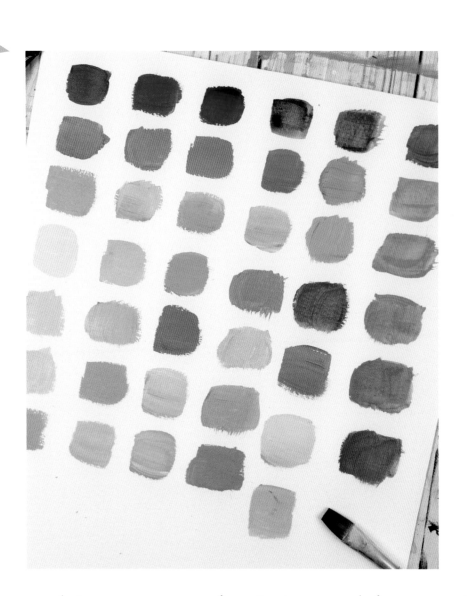

 Don't be afraid to use colors that you don't like as much or that aren't what you'd consider pretty. Dull, muted colors contrast beautifully with bright, vibrant colors.

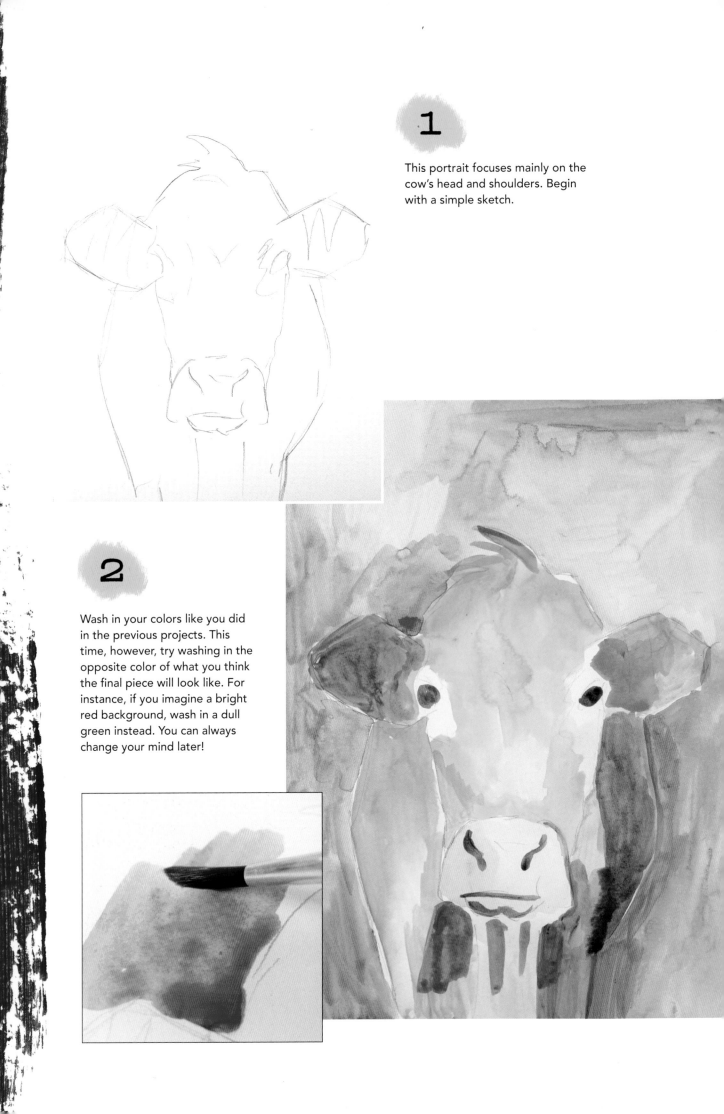

1

This portrait focuses mainly on the cow's head and shoulders. Begin with a simple sketch.

2

Wash in your colors like you did in the previous projects. This time, however, try washing in the opposite color of what you think the final piece will look like. For instance, if you imagine a bright red background, wash in a dull green instead. You can always change your mind later!

3 Block in the dark values first, followed by the medium ones, and then the light. Be sure to block in the opposite color of your wash (unless you've chosen to do something different, in which case, go for it!).

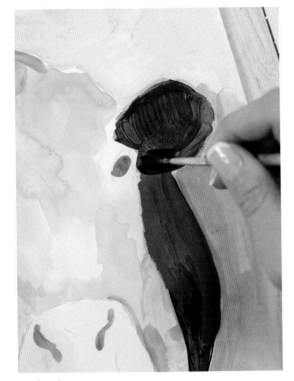

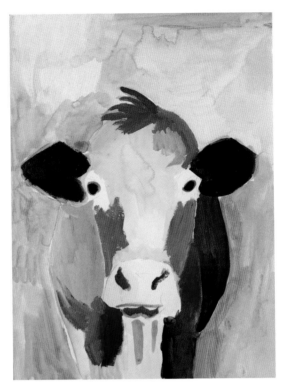

Dark values

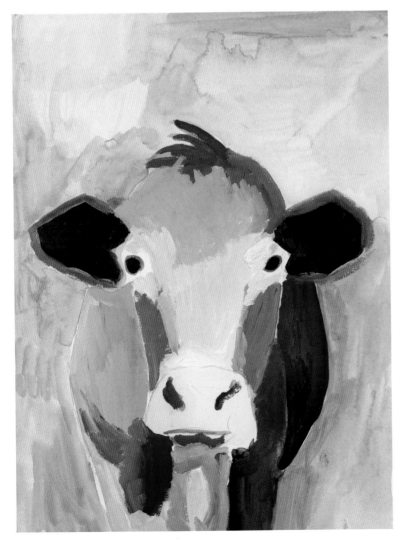

Keep in mind that bright, light colors appear to pop out, while dark, dull colors tend to recede. For this reason, I chose to apply brighter colors to the cow and duller colors in the background.

Medium/light values

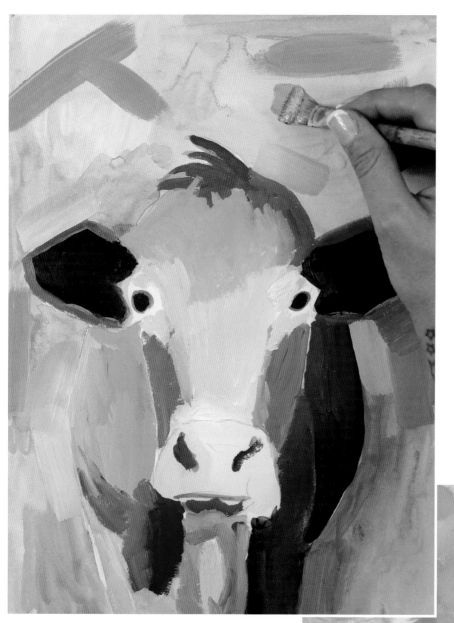

4

I decide to get even funkier with this piece and use a flat brush to apply different hues of dull green, purposefully leaving small bits of the red wash showing through. The drybrush technique (see page 12) is wonderful for capturing expressive brushstrokes and gives a scratchy look to the paint.

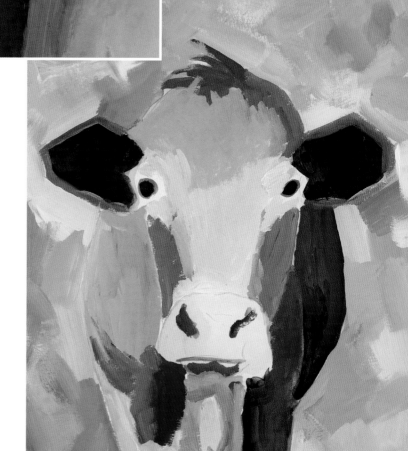

5 To make the cow's face pop forward, use duller hues for the body and brighter hues for the face. Work with a fast and free painting style.

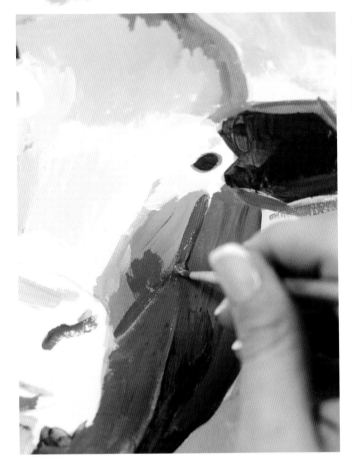

As you paint, keep your movements loose and expressive.

I use linear strokes to give the piece an edgier, more impressionistic feel, instead of trying to capture a realistic cow.

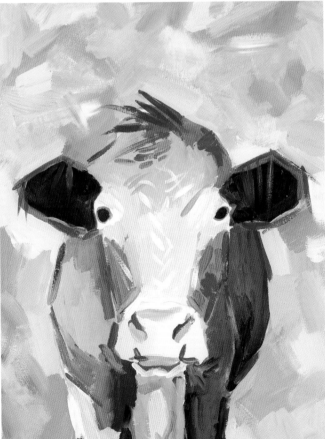

6

Add more details! Remember: Acrylic painting is about layering and building from the ground up.

I use a smaller brush to add detail to the cow's eyes, ears, and nose. However, to keep the expressive feel, I continue to work with linear brushstrokes.

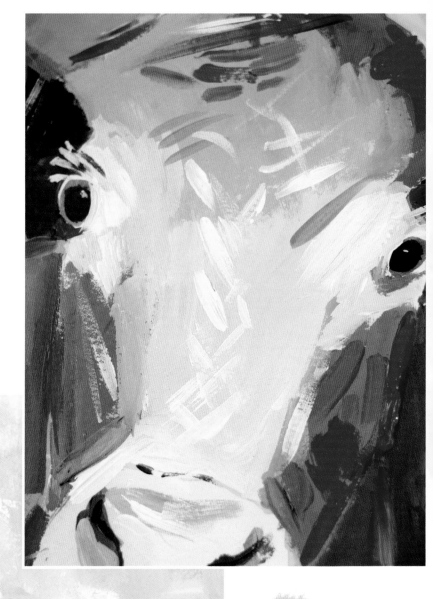

7

To finish up the portrait, I work on adding more and more layers of linear strokes. How do I know I'm done? I just feel it!

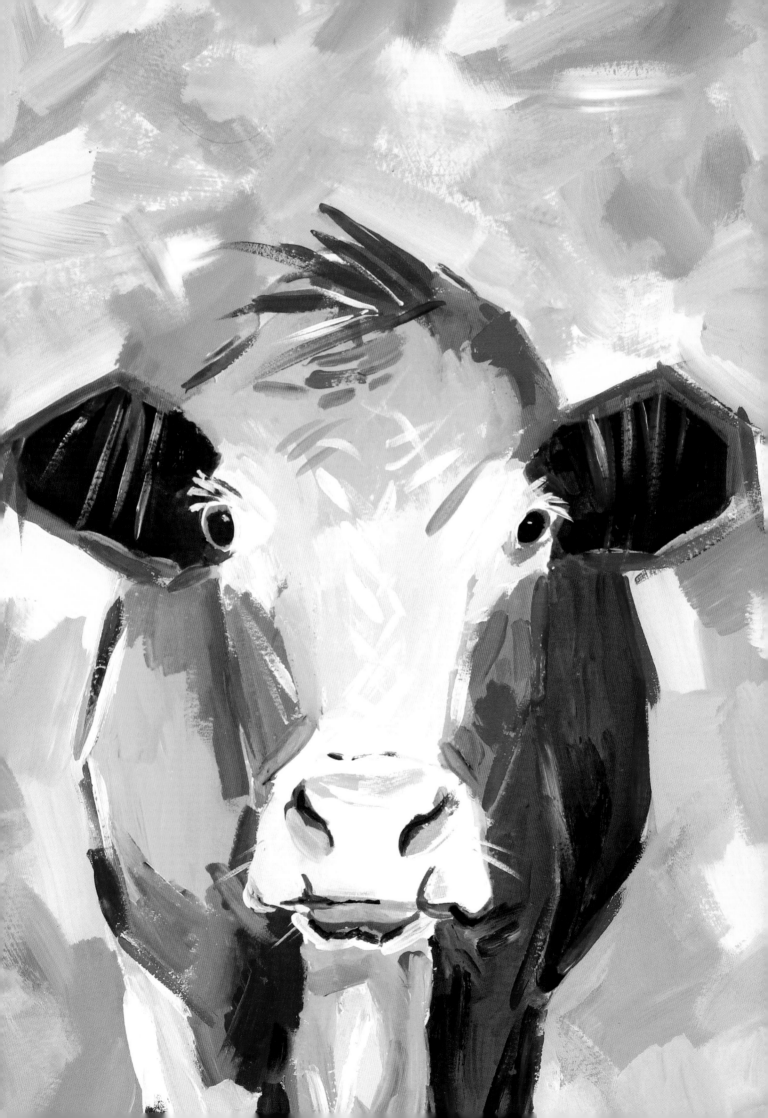

Split Complementary Cat

Say hello to a super-fun color scheme! A split complementary color scheme is similar to a complementary color scheme; however, instead of choosing a color and its opposite, you will select a color and the colors to the right and left of its opposite.

This color scheme displays a strong visual contrast, but it's less intense than a complementary color scheme, making it easier on the eyes.

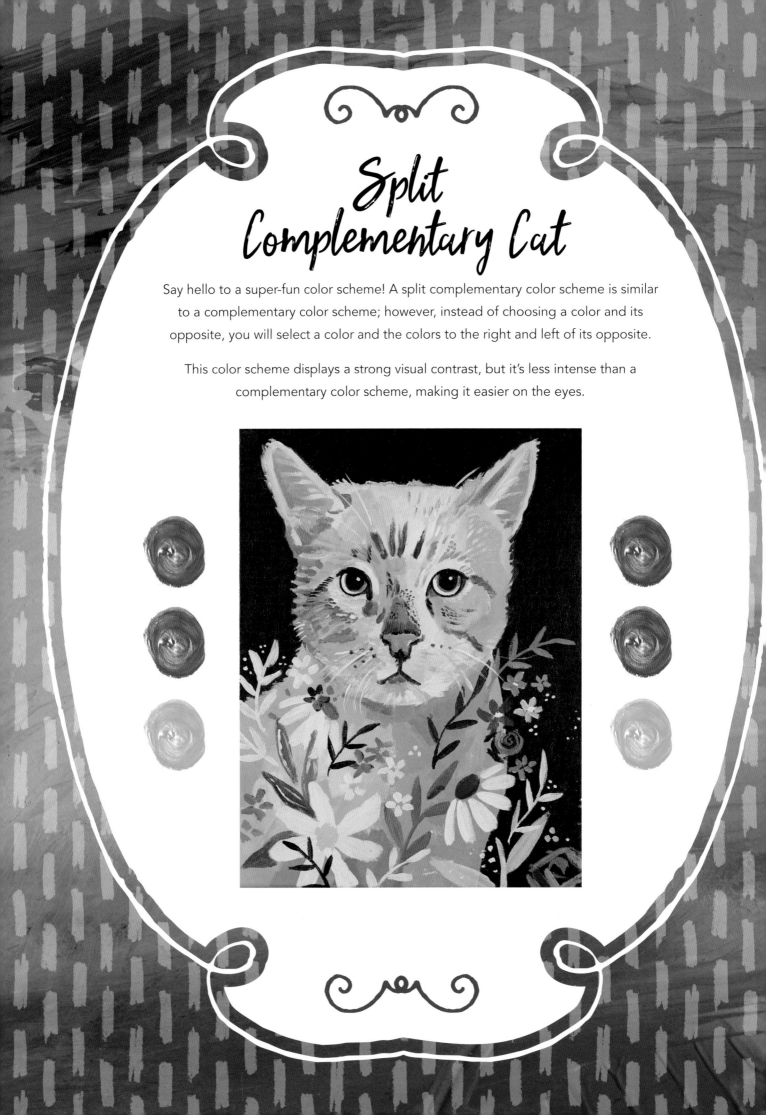

In this project, we're going to use our imaginations and place the cat in a magical garden filled with flowers, leaves, and fun doodles!

Once again, I recommend not only using a full range of values (light to dark), but also a full range of intensities (bright to dull). You can see my palette here. I chose yellow, blue-violet, and red-violet for my color scheme.

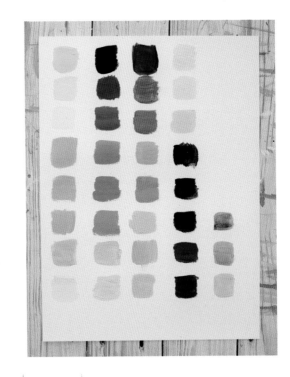

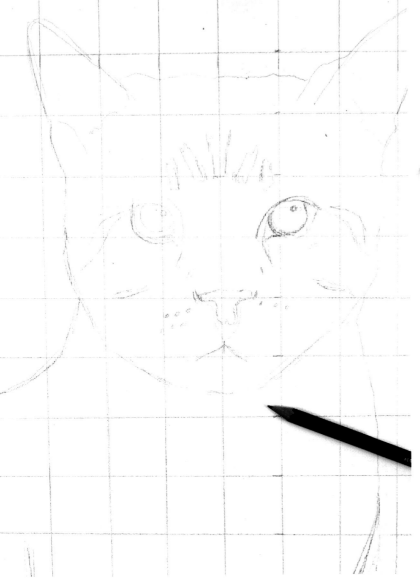

1

Lightly sketch in the cat. I choose to work on canvas this time, and once again, I use the grid method to create a very accurate sketch (see page 23).

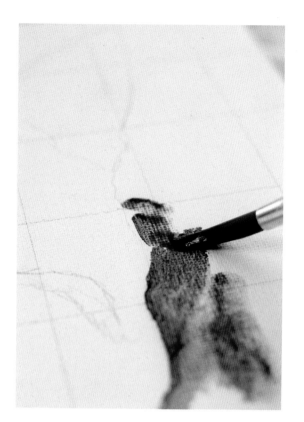

I encourage you to be more expressive with this piece. Add patches of color and stretch your palette to use as many variations of your color choices as possible. You may even want to set aside your reference image so that you truly paint from your gut.

2

Next, wash in color, starting with your darkest values. I choose a dark blue-violet for my darkest areas and background, and values of yellow and red-violet for the rest of the piece.

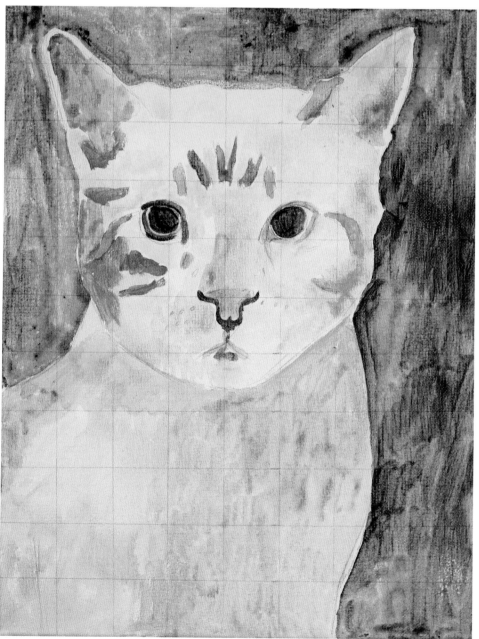

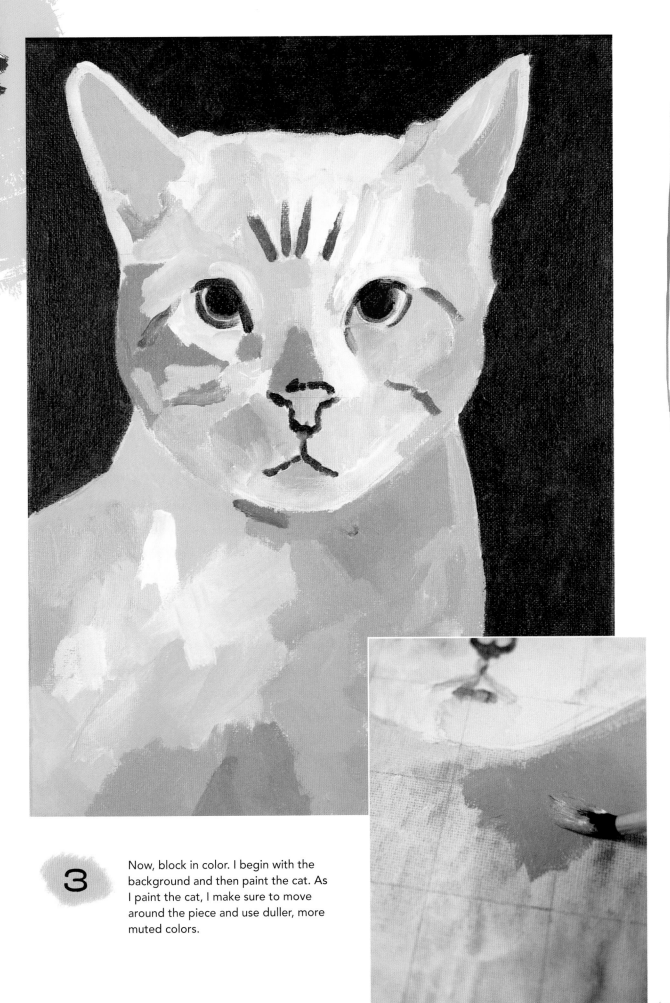

3 Now, block in color. I begin with the background and then paint the cat. As I paint the cat, I make sure to move around the piece and use duller, more muted colors.

4

Begin building up the cat's facial details.

When painting fur, remember to paint in the direction of hair growth. As you continue to build up this next layer, keep this in mind and adjust your brushstrokes accordingly.

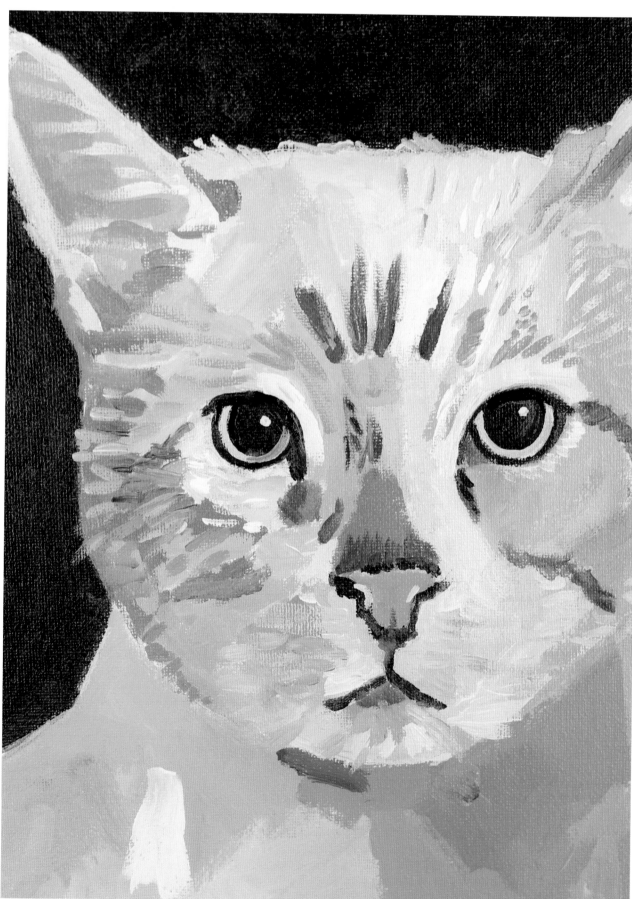

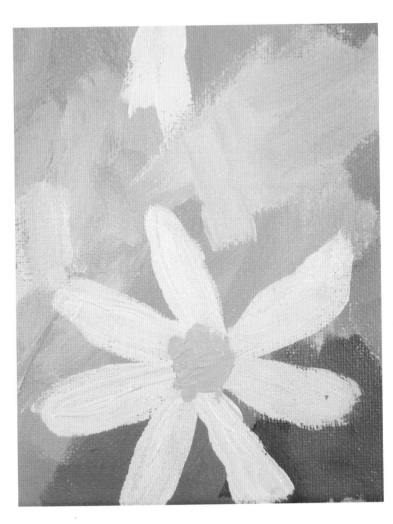

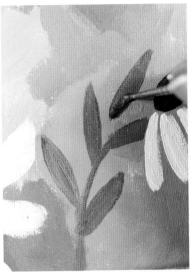

5

Are you ready for the really fun part? Now you get to use your imagination and create a whimsical, expressive garden for your cat to live in.

With vibrant red-violets and yellows, I create whimsical floral shapes. You can make your flowers as realistic or as funky as you want!

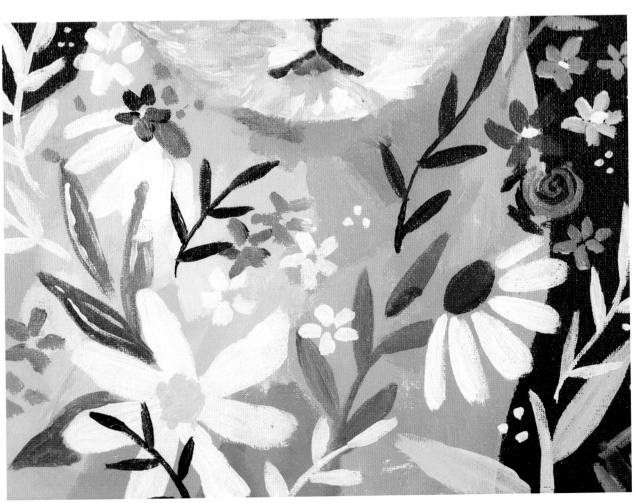

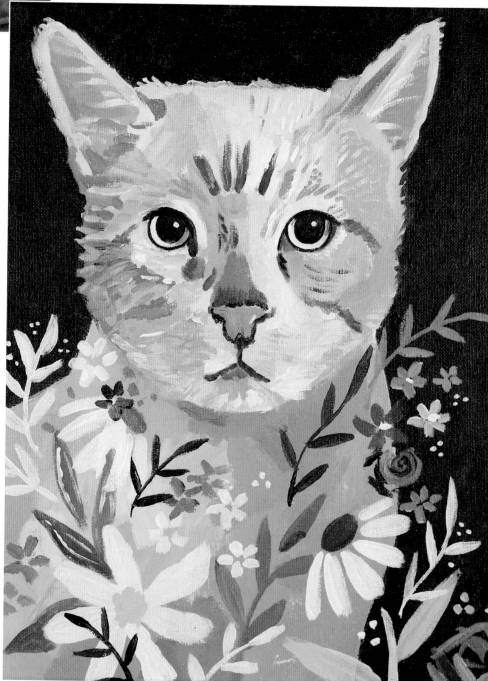

6 I use simple shapes to create leaves, vines, daisies, and roses. I also let the florals creep into the background and overlap one another.

For fine line work, such as the whiskers and final layers of fur, I like to use high-flow acrylic paint to achieve a smoother line.

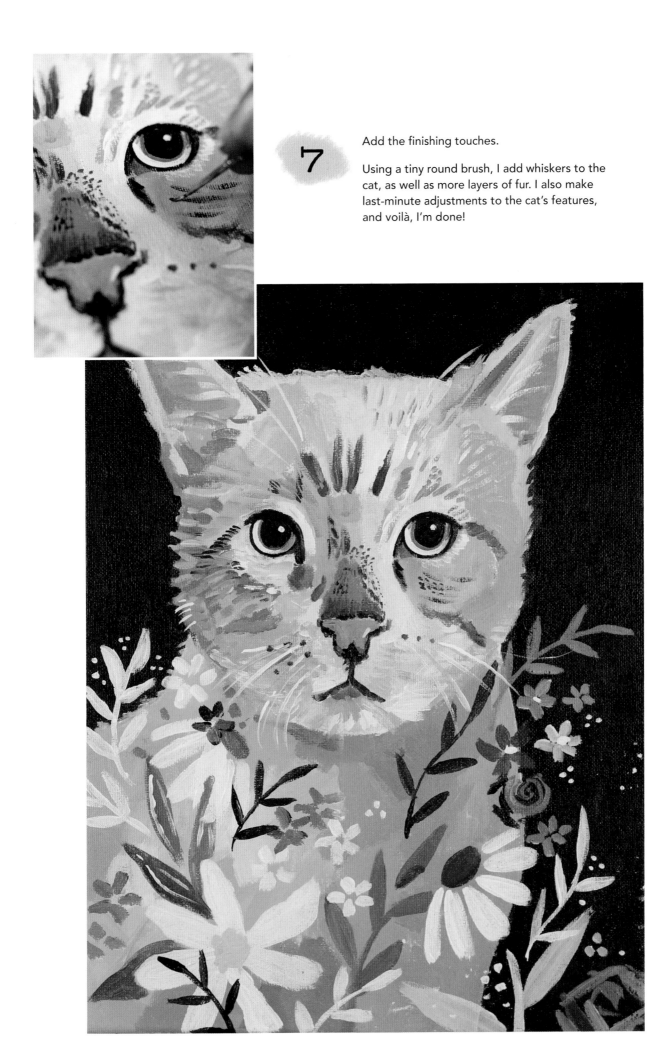

7 Add the finishing touches.

Using a tiny round brush, I add whiskers to the cat, as well as more layers of fur. I also make last-minute adjustments to the cat's features, and voilà, I'm done!

Triadic Raccoon

Our next piece uses one of my favorite color schemes: a triadic one. I love it so much that we are going to explore two different variations in this book, starting with this yellow-green, blue-violet, and red-orange raccoon.

A triadic color scheme is comprised of colors that form a triangle on the color wheel. For instance, the primary colors—yellow, red, and blue—create a triadic color scheme, as do the secondary colors, or green, orange, and violet.

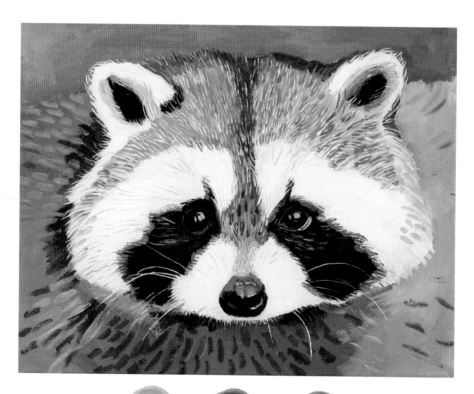

As usual, I fill up a page of color swatches to get a sense of what my palette will look like. Painting these swatches also gives me extra practice with mixing colors and creating different values and intensities.

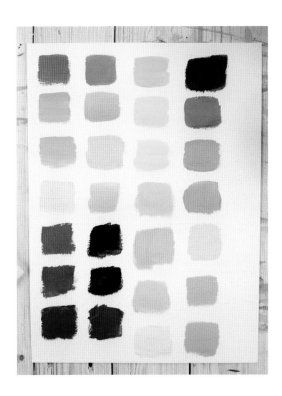

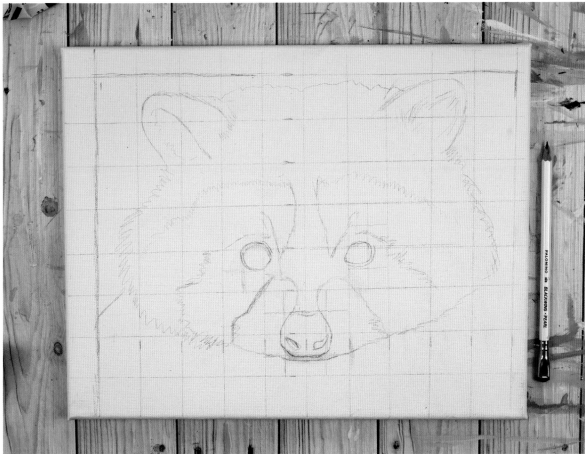

1 Lightly sketch in the raccoon.

Once again, I use the grid method (see page 23) and work on canvas. This time, however, my reference photo is a close-up, horizontal image of a raccoon's face.

2

Use burnt umber to add a warm brown wash and create an underpainting across your entire canvas. Add less water to your paint this time; you want to lay it on thicker than you did in previous projects. The brown will produce a high level of contrast when brighter colors are added on top.

Because of this, some artists prefer this method. See which you like better! You can stick with shades of brown or use all the colors in your palette.

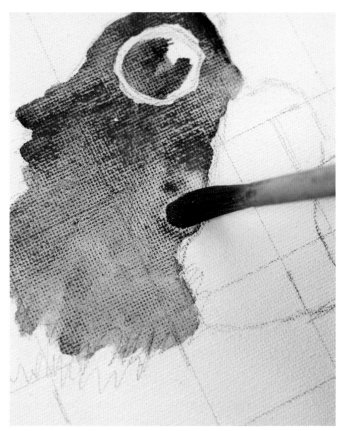

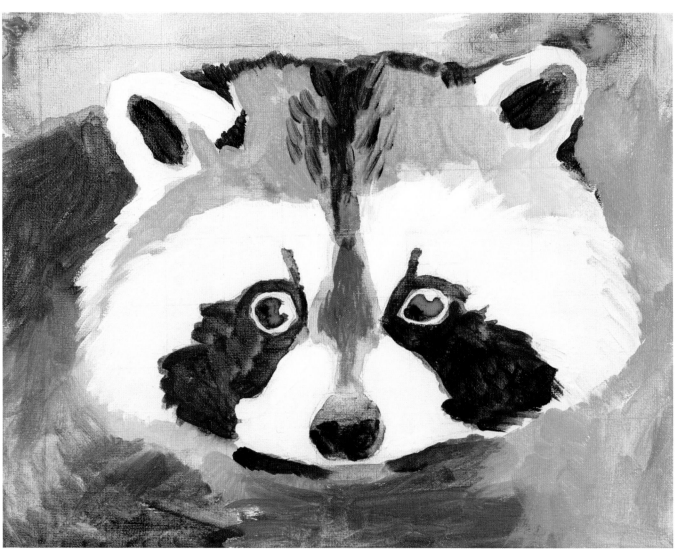

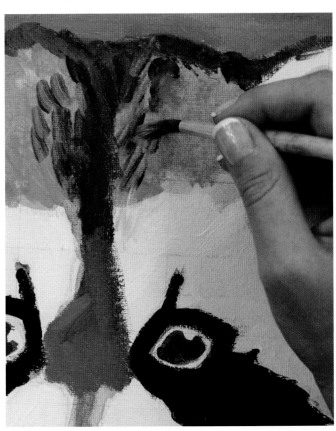

Now it's time to paint the second layer. Remember to work throughout the painting instead of building up details in one tiny area.

You don't need to address the raccoon's fur yet, but you should still place your brushstrokes in the direction of fur growth.

I choose to paint the background a deep red-orange. Although I don't use this color in the raccoon's body, I plan to add pops of red-orange in the fur later.

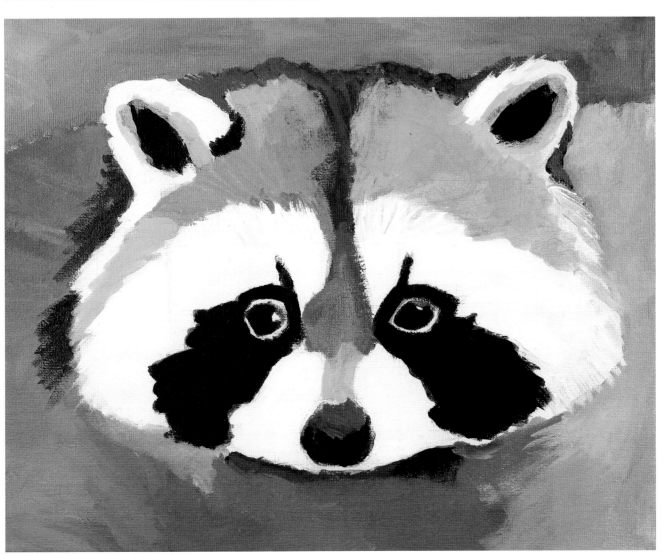

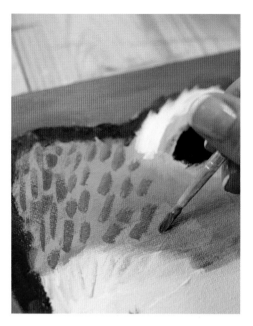

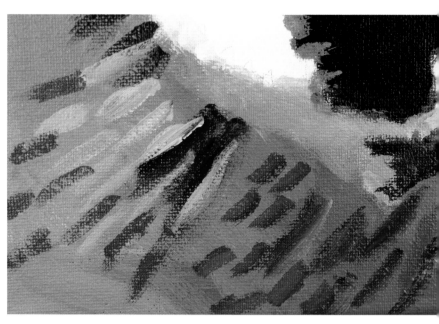

4

Build up the fur by layering colors.

In the medium tones of the raccoon's face, I use a dulled yellow-green and then paint blue-violet brushstrokes on top.

I also add red-orange on top of the blue-violet in the raccoon's body and a medium-valued color to soften the edges.

.

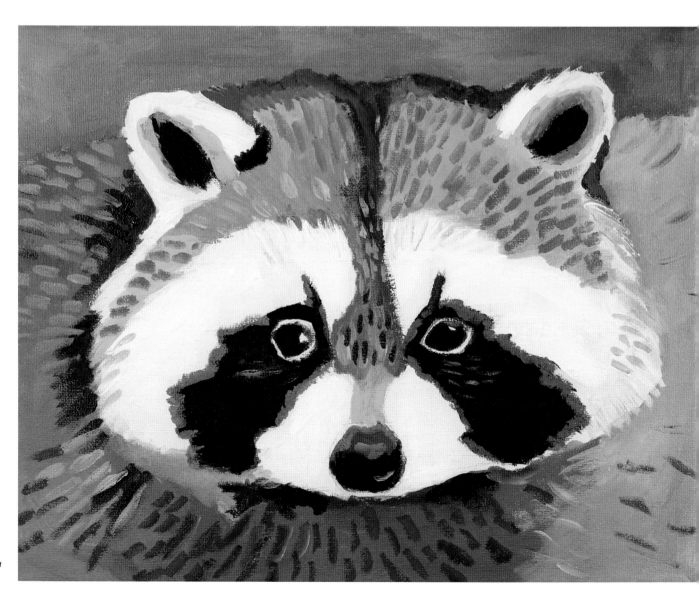

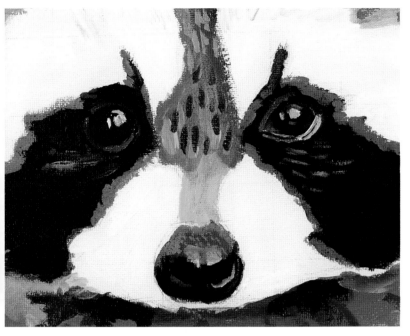

Paint the raccoon's eyes and nose. These features are among the most eye-catching elements of any face, whether human or animal.

Because this is such a close-up portrait of the raccoon, I spend extra time painting its eyes and nose, adding as much detail as possible.

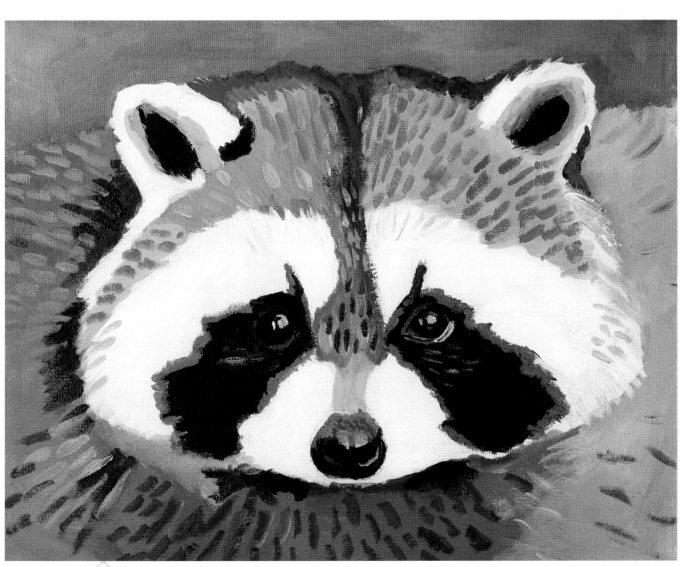

Just as you add detail second, it's also good to paint from back to front.

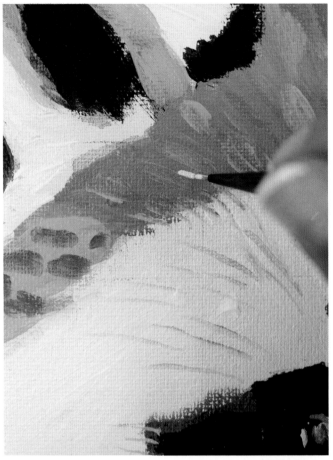

6

Add the third layer of fur.

I use a very small round brush and work throughout my entire piece to paint very fine lines. Notice how the layers of color create dimension.

Pay attention to your values as you paint. Areas with more darks and shadows will have less-visible hairs.

Make sure your paint is nice and fluid. Use high-flow acrylics (see page 6) or water down your acrylic paint to ensure that you create smooth brushstrokes as you finish your piece.

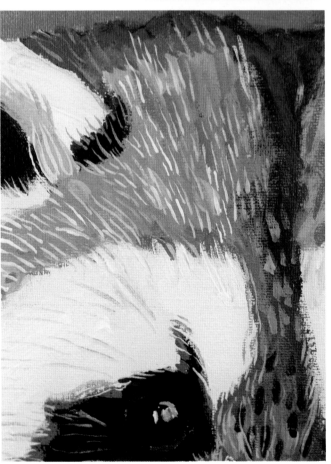

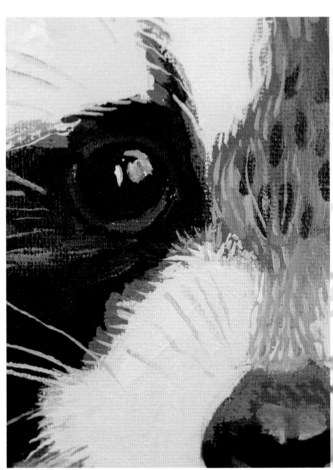

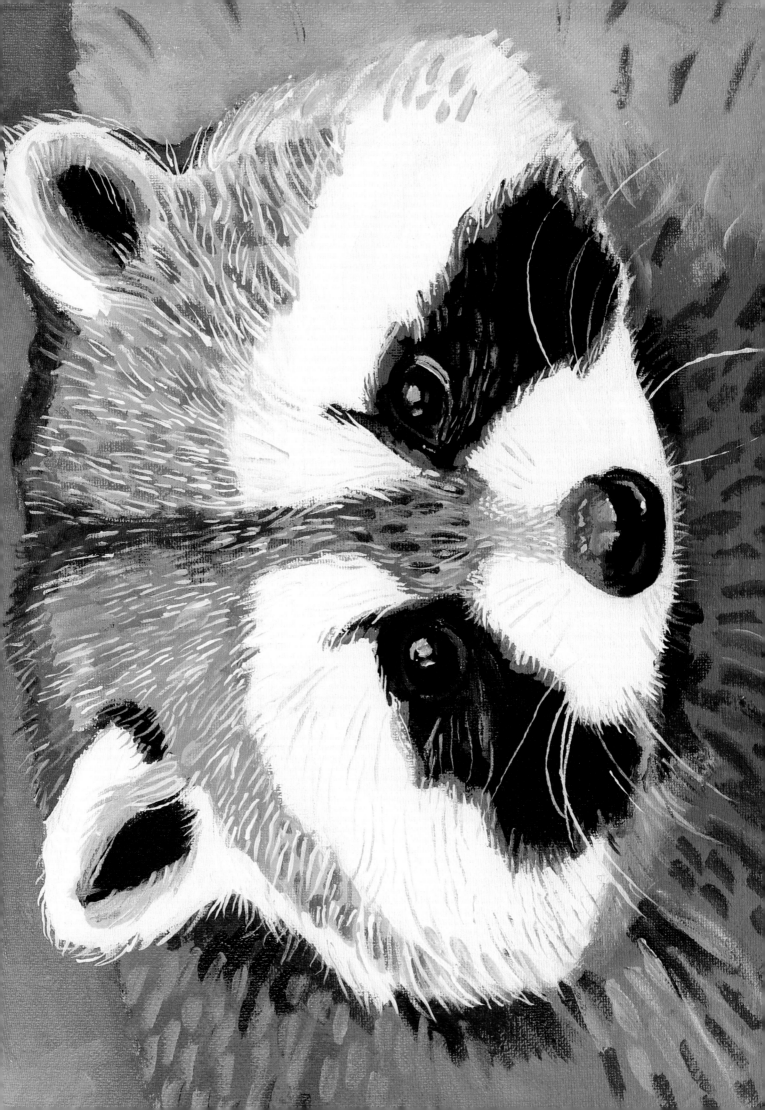

Triadic Giraffe

This project will challenge you to use a triadic color scheme consisting of the three primary colors: red, blue, and yellow. This can be a tricky color scheme to pull together, but using the knowledge you now have about mixing intensities and values, I know you can make it work!

The combination of these three vibrant colors can be a little jarring, so it's important to balance your bright colors with duller ones.

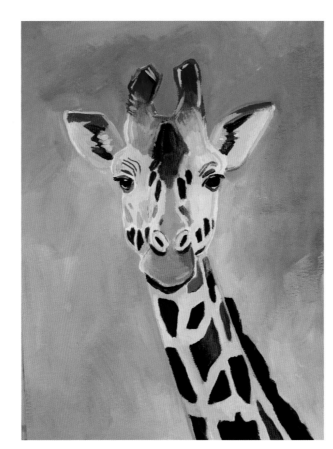

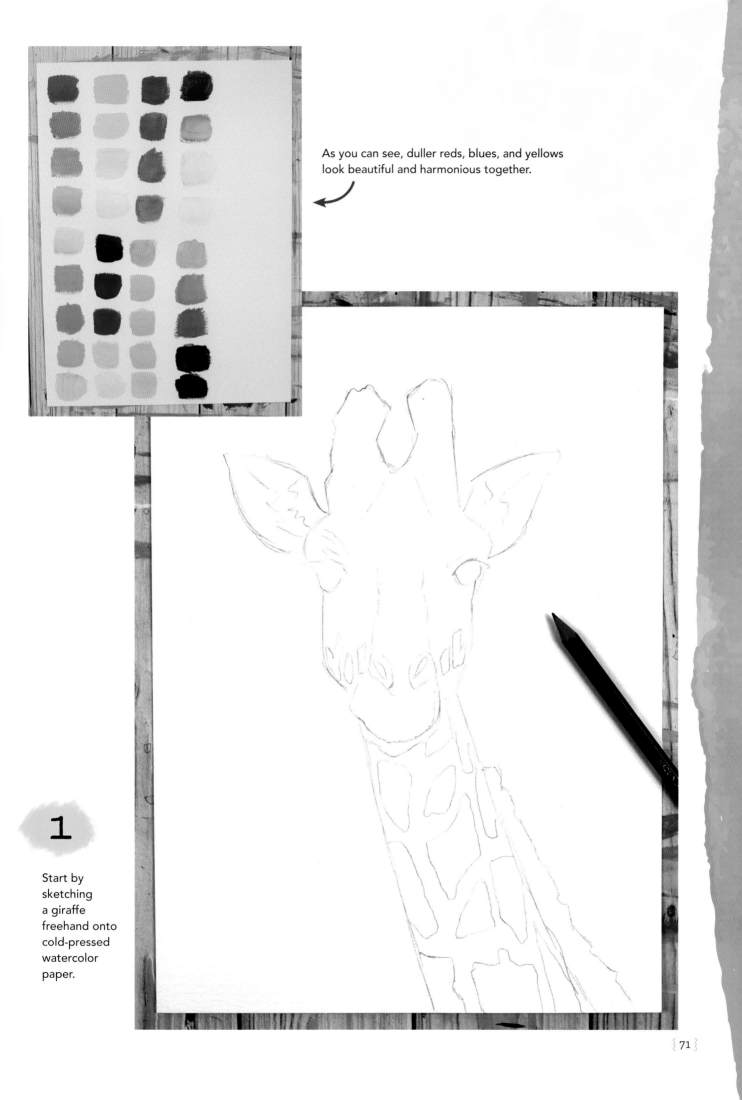

As you can see, duller reds, blues, and yellows look beautiful and harmonious together.

1

Start by sketching a giraffe freehand onto cold-pressed watercolor paper.

2 Again, use a full range of brown values for the first layer (the underpainting).

This time, I apply the paint in a thicker manner, rather than using a wash. I use a warmer brown for the background to distinguish it from the foreground.

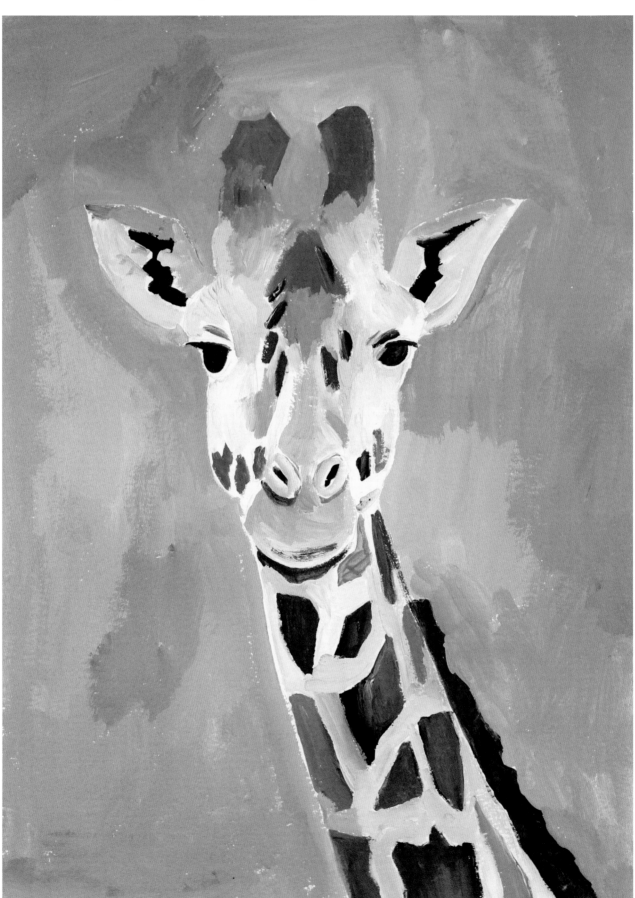

Which method do you like better: a wash or an opaque first layer? An underpainting typically uses thinned color, but I believe it's best to go with what works for you. Try both methods and see what you prefer!

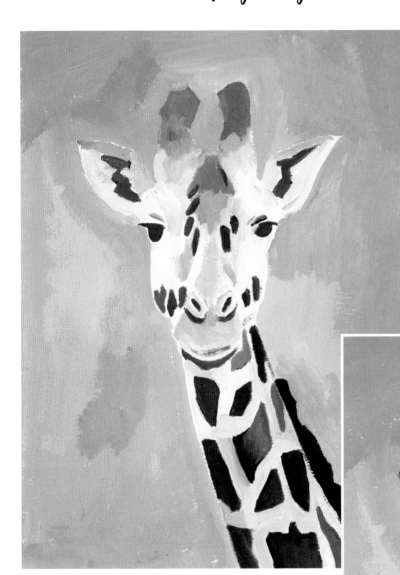

3

Begin the second layer by painting your darkest values first, followed by medium and light values.

I choose to use a dark, dull blue for most of my darkest values. Choose one color, or mix it up—it's your decision!

For my medium and light values, I alternate between reds and yellows, again utilizing duller hues.

4 Now, address the background.

I like the brown background, so I decide to build on it, creating soft, subtle variations throughout. I cool it down quite a bit by adding a touch of ultramarine blue, which ultimately lightens up the value as well.

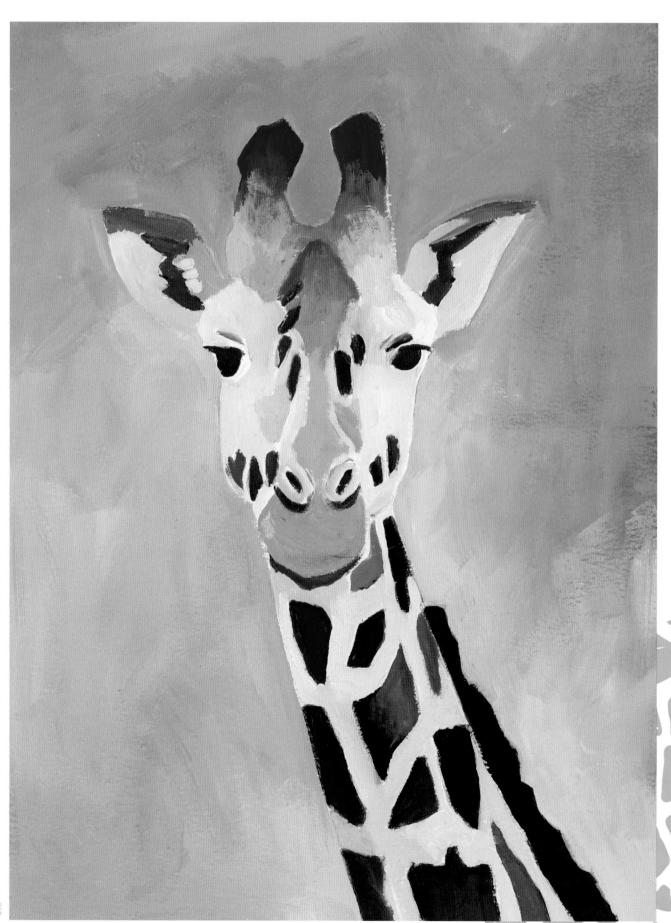

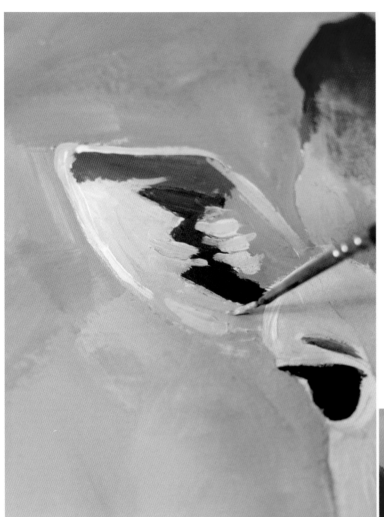

5

Work on the third layer of paint in the giraffe, and look for areas where you can add brighter, lighter colors. The contrast between the bright highlights and mostly dull palette will look beautiful. Build up details as you continue adding paint.

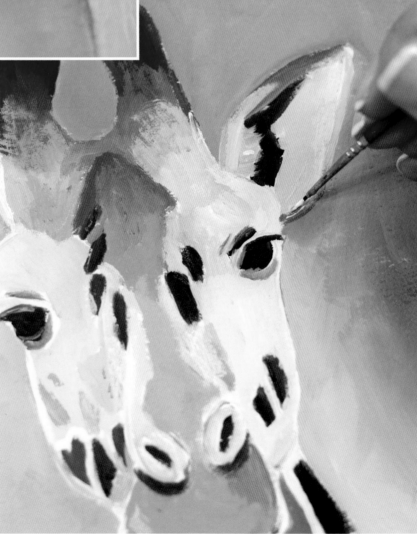

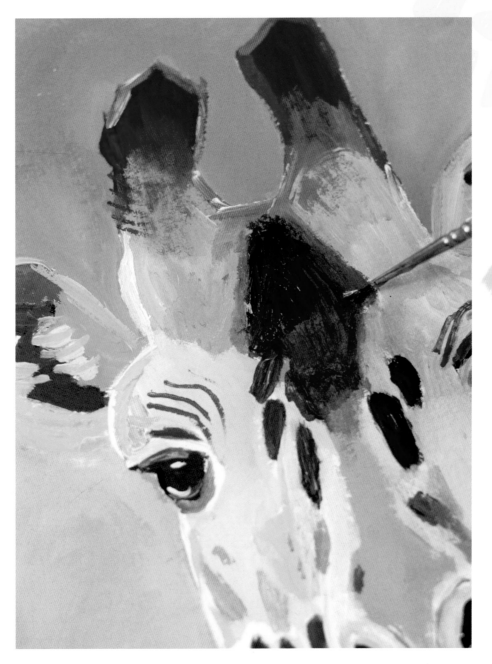

6

I add most of the brighter highlights to the giraffe's face and along its edges. The pops of bright color around the edge of the giraffe help set it apart from the background.

7

Fine-tune and complete your painting!

I continue to add expressive, linear brushstrokes of light, bright colors to finish the giraffe's features.

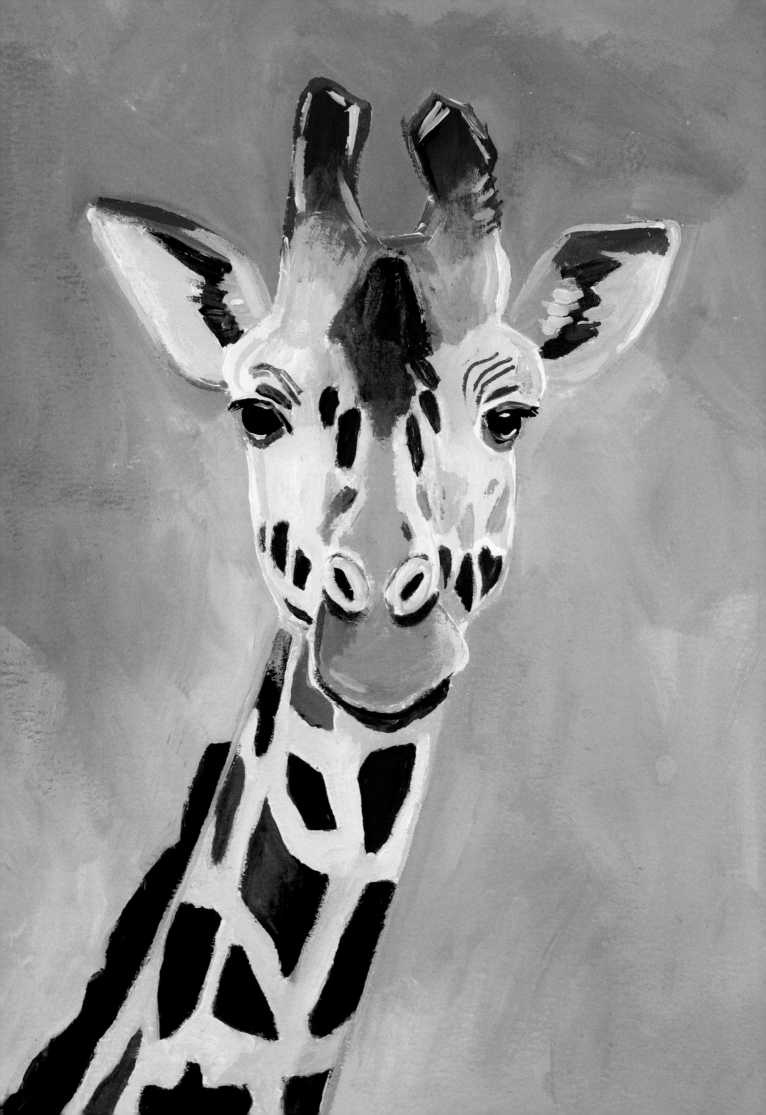

Tetradic Llama

A tetradic color scheme uses four colors, or two pairs of complements. Red, green, blue, and orange make up a tetradic color scheme. Or, as you'll see in our cute little llama, red, green, blue-violet, and yellow-orange also work as a tetradic color scheme.

This type of color scheme looks rich and vibrant—but not always harmonious. As with each color scheme we've worked through thus far, push yourself to use a range of values and intensities.

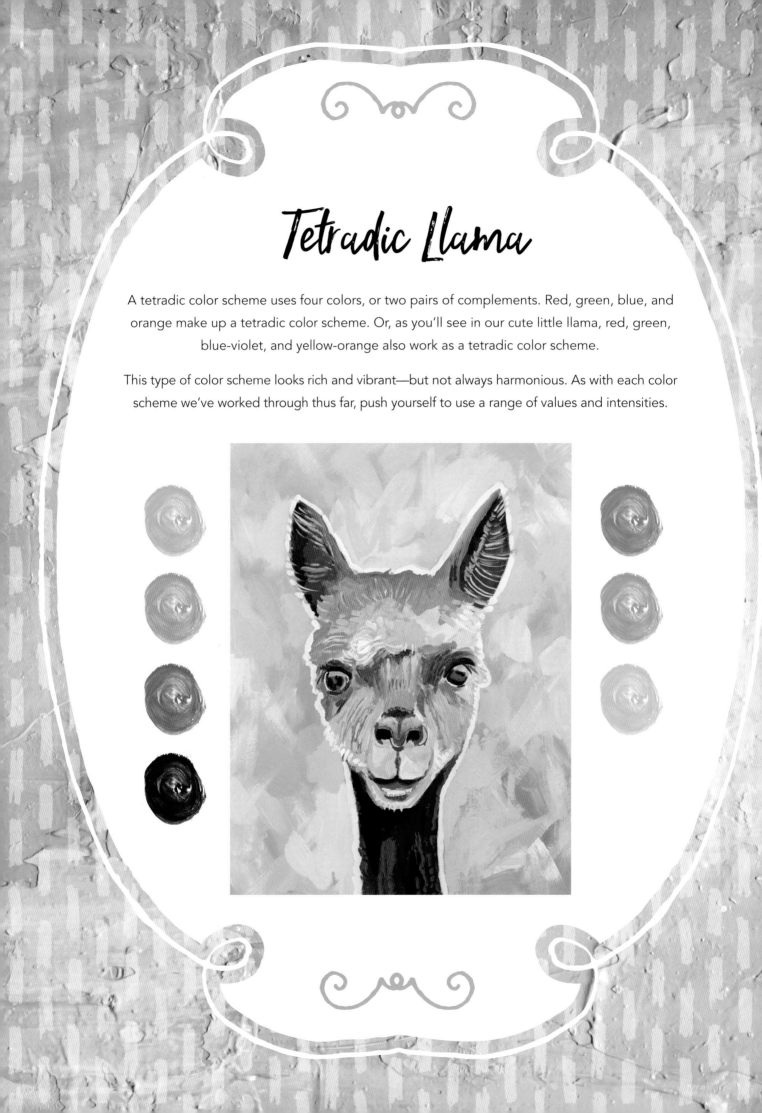

Make some color swatches to illustrate your color palette before you begin.

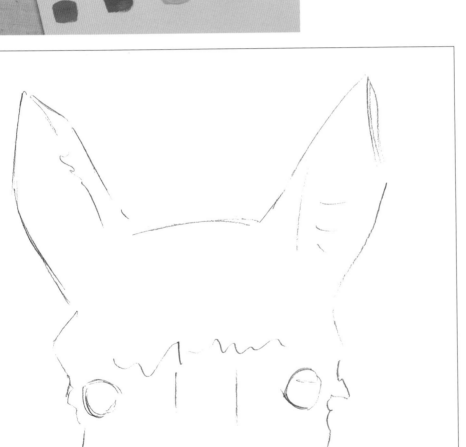

1

Lightly sketch a llama.

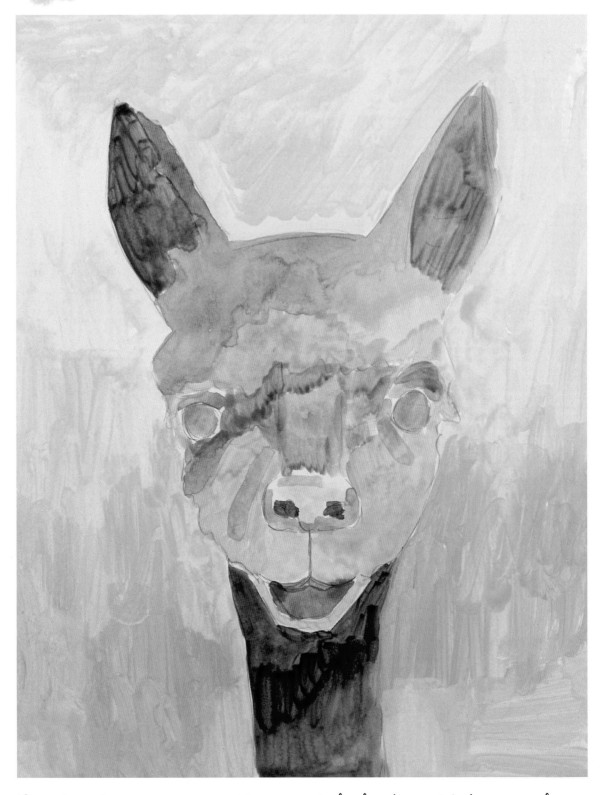

Remember: You are never married to your initial color choices. Washing in color gives you a first coat of paint, as well as an idea of what your final piece will look like. With acrylics, you can paint over certain areas, so don't stress about your initial wash of color; you can always change it later!

Block in the background and the dark values in the piece.

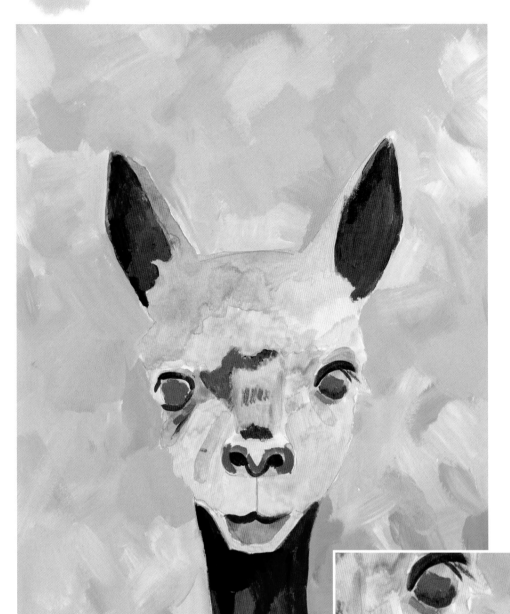

Try to balance the bright with the dull colors. The tetradic color scheme can overwhelm the eye if you aren't careful, so make sure you include some dull colors.

I choose light dull green for the background and dark blue-violet for the darkest values.

To make the background expressive, I mix up the values of the dull green and used a large, flat brush to slap on the paint.

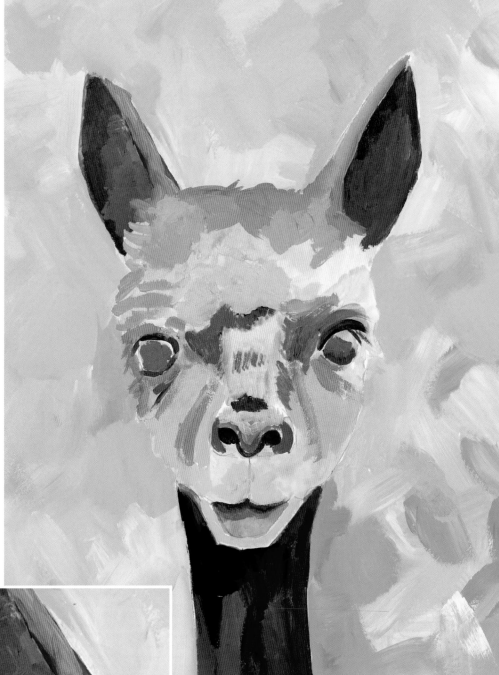

4

Block in the medium and light values.

I choose red for the medium tones and a dull yellow-orange for the lighter tones, and let the direction of the llama's fur growth guide my brushstrokes.

5

Now, build up the details.

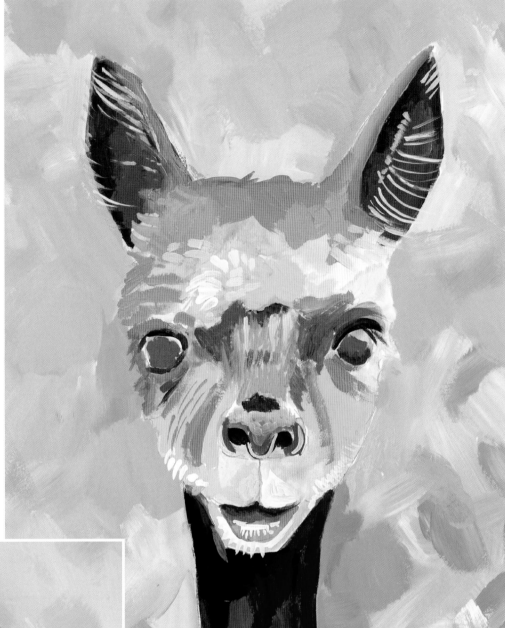

The llama is a furry, silly-looking creature, and capturing its fur gives you the opportunity to be expressive and free and really show off the llama's quirky look. Use a thin round brush to paint layers of lines of different colors, values, and details to the llama's face.

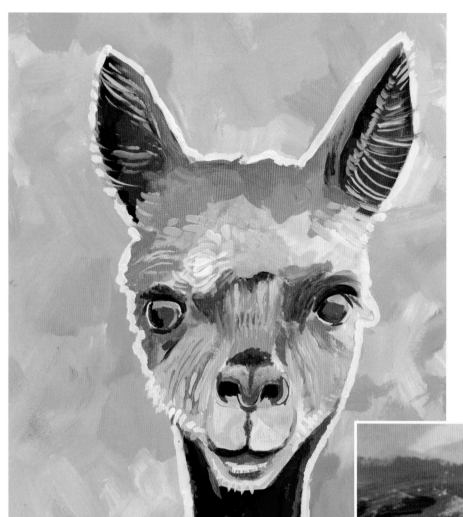

6

I love an illustrative look, so I decide to create a white outline around the llama. It plays off the white highlights and adds a bit of fun to the piece (As if the colors weren't already fun, right?)

7 With a small brush, add overlapping strands of fur.

8 It's never too late to make changes! After getting this far with the llama, I decide to add mint green to the background. The dull greens just weren't working for me, so I made the change and ended up happy!

Consider the tetradic color scheme and whether your piece needs anything more before finishing it up.

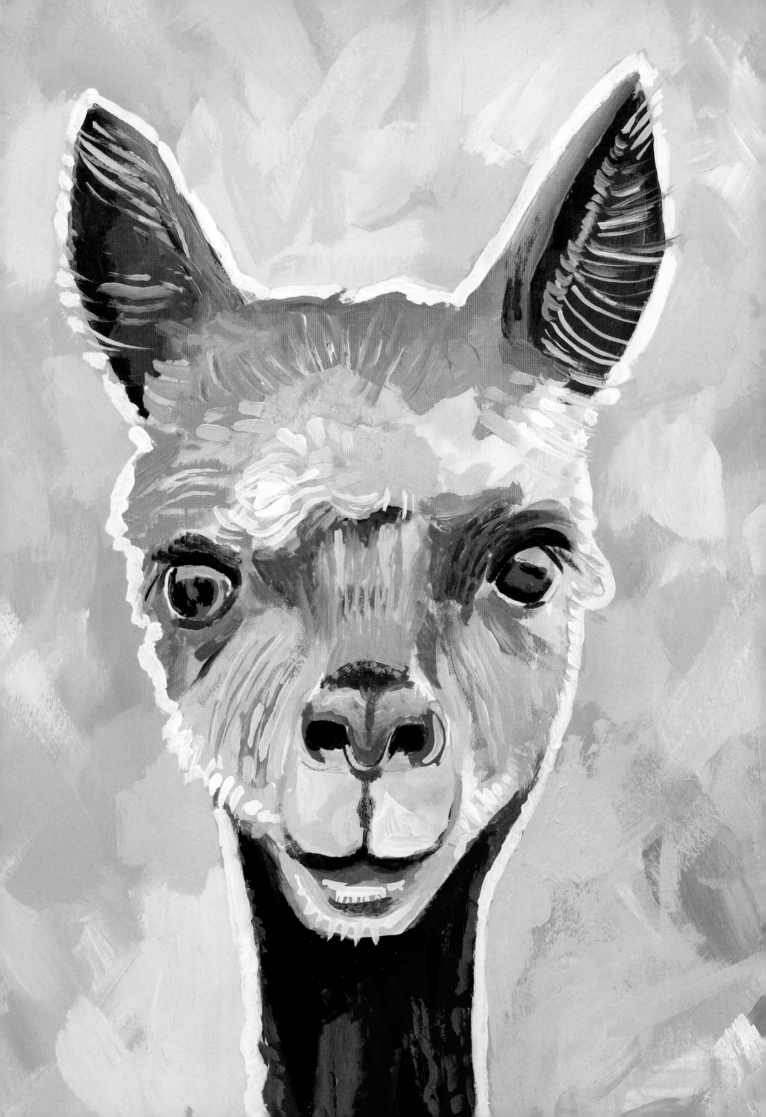

Paint Swatch Elephant

This next project is going to require a bit of a field trip.
Visit your local hardware store and collect some paint swatches (I love keeping
these around; I have stacks!) to use in your next painting.

You won't just use the paint swatches to create a color scheme; you're also going to collage
pieces of the swatches into your painting to give it some unexpected texture. You'll match the
colors of the swatches to your paint, which will help you improve your color-mixing skills.

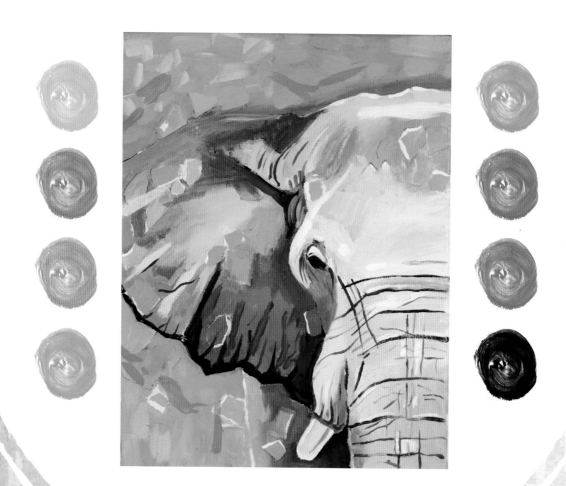

Once you have your swatches, use them to create your own color scheme consisting of five colors. You can cut them up and mix and match; however, make sure you take some time to find five hues that work for you. And by "work," I mean five colors that appeal to you. Forget about all the color schemes you've learned thus far, and just go with your gut.

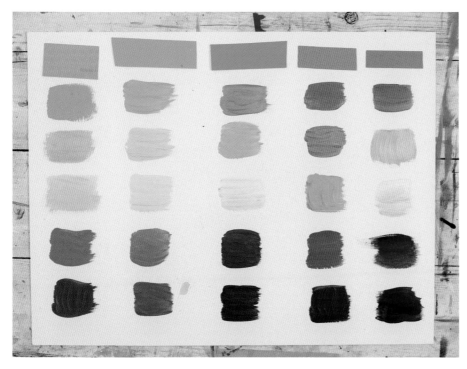

Now, expand your palette by creating values of each of the hues. Try to match the paper swatch exactly for your first value.

As you mix and match colors, ask yourself the following questions:

- What is the base color of the swatch?
- Is your paint mixture darker or lighter than the swatch? If it's darker, add white.
- Is your paint mixture warmer or cooler?
- Is your paint mixture brighter or duller?

Remember: The best way to improve your color-mixing skills is to keep mixing!

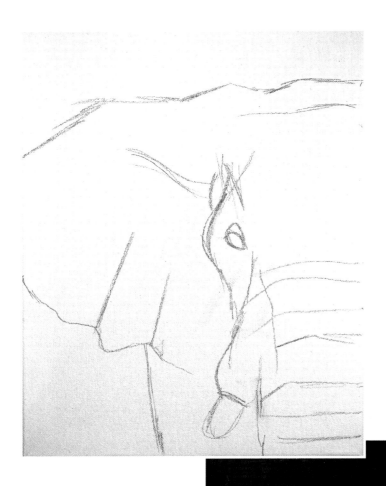

1

Begin your painting the same way you've done for the other projects by sketching an elephant onto canvas.

2

Apply a wash or an underpainting; I add an underpainting in brown.

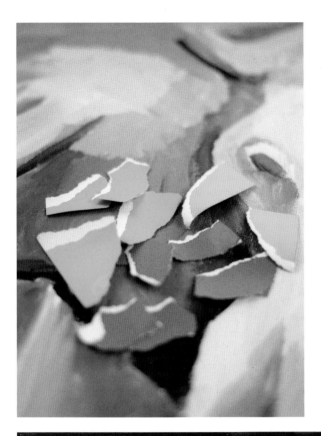

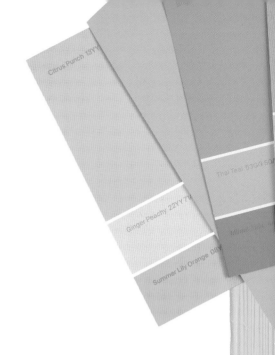

3

Tear up some of your paint swatches.

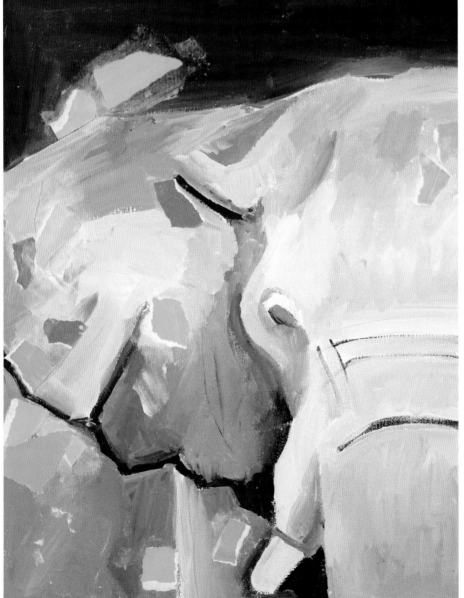

4

Use acrylic gel medium to paste the swatches throughout your piece. Brush the gel medium onto the back of each swatch, and then seal it with another coat on top. The gel medium will dry clear.

There is no formula for where to place your swatches! I randomly choose spots throughout my painting.

Let the gel medium dry before continuing.

5 Begin blocking in color throughout the piece.

6

Use the color swatches as guidelines for where to add different colors. As you block in your colors, pay close attention to the values in your underpainting and match them accordingly.

7 Let some of your paint swatches show, and paint over others.

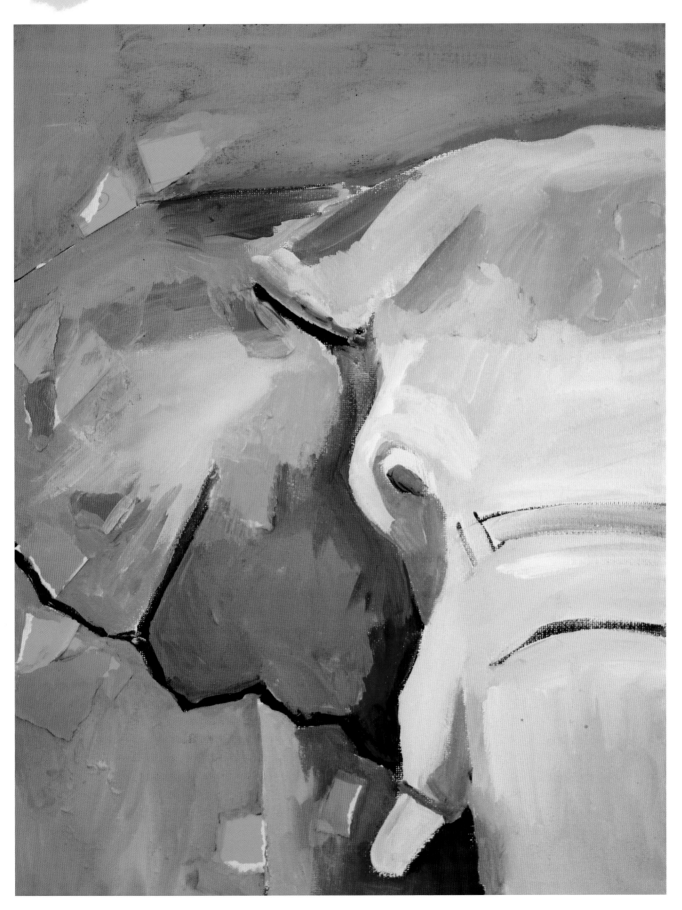

8

Begin adding detail. Elephants are wrinkly creatures; try to capture those folds through line work.

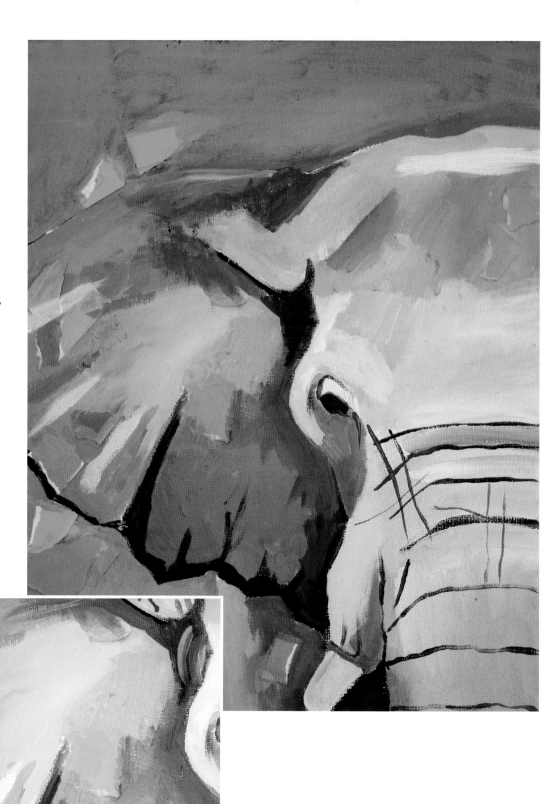

Mix up the colors you use in the wrinkles to add even more visual interest to your piece.

9

Next, address the background.

Because my palette is bright and fun, I decide to add playful brushstrokes in the background.

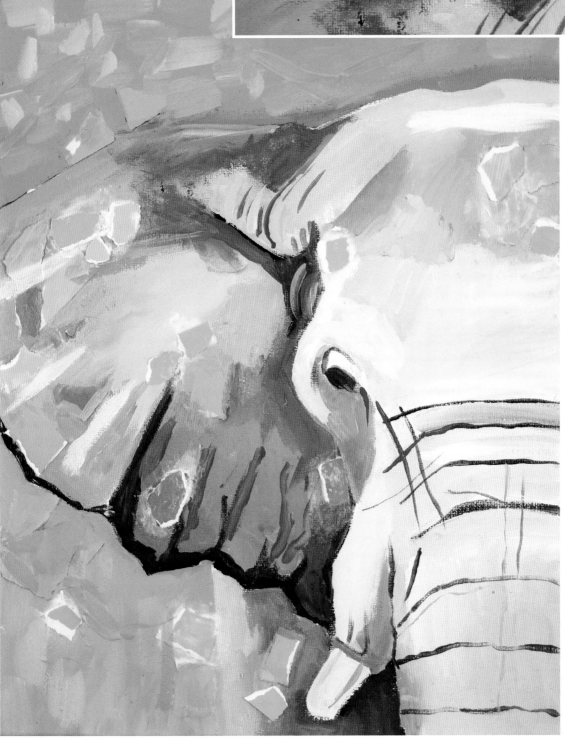

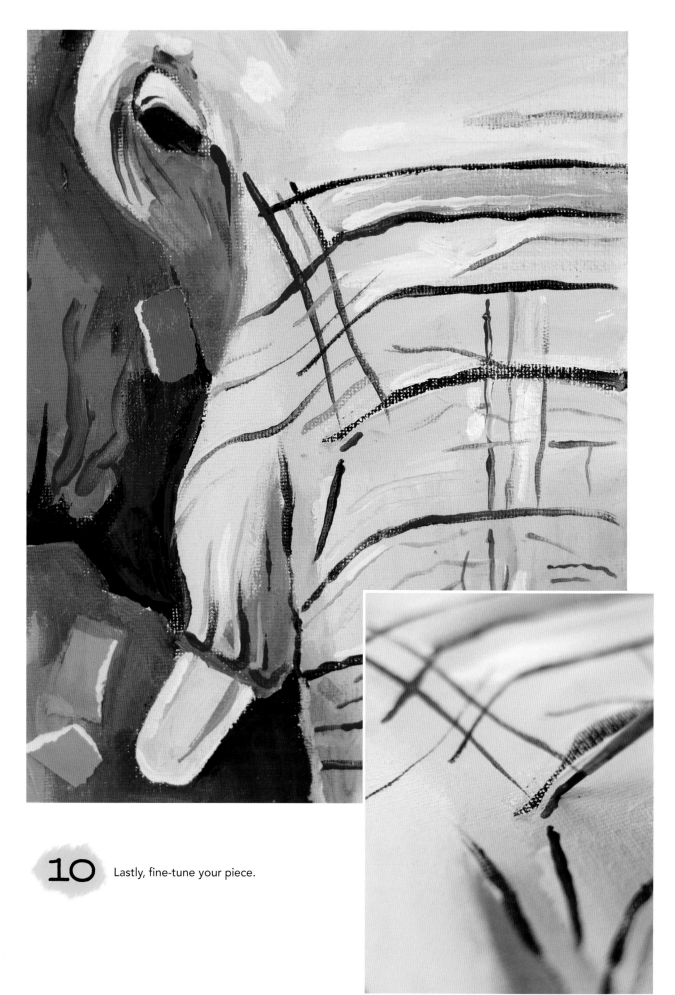

10 Lastly, fine-tune your piece.

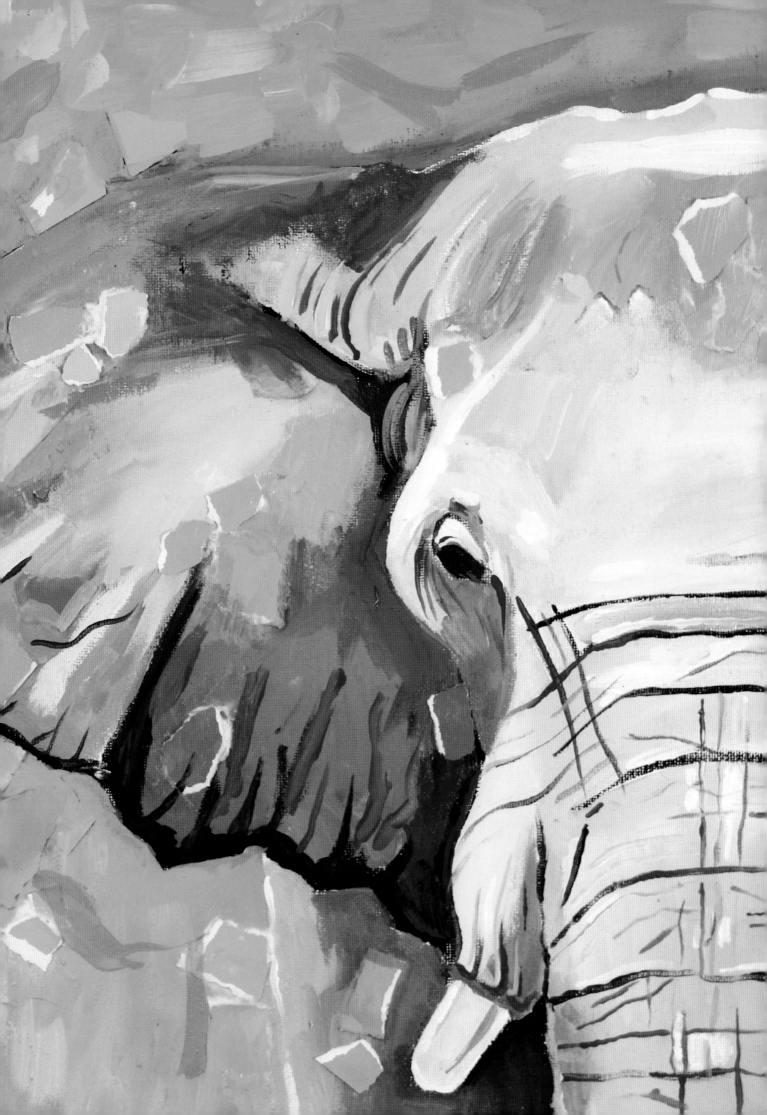

Color-as-Value Flamingo

For this color scheme, let's look at each color as having a value, with violet as the darkest value and yellow as the lightest. I encourage you to use a black-and-white image as your reference; it will allow you to focus on the values, not the colors.

For this project, don't use black or white to create tints and shades. Instead, use the colors just as they appear on the color wheel. Avoid dull colors; this piece should look extra bright and vibrant with fully saturated color.

Imagine yellow as white and violet as black, and all the other colors as midrange. When you want to blend violet from dark to slightly lighter, add blue or red. To darken your lightest value (yellow), add red or blue to create orange or green.

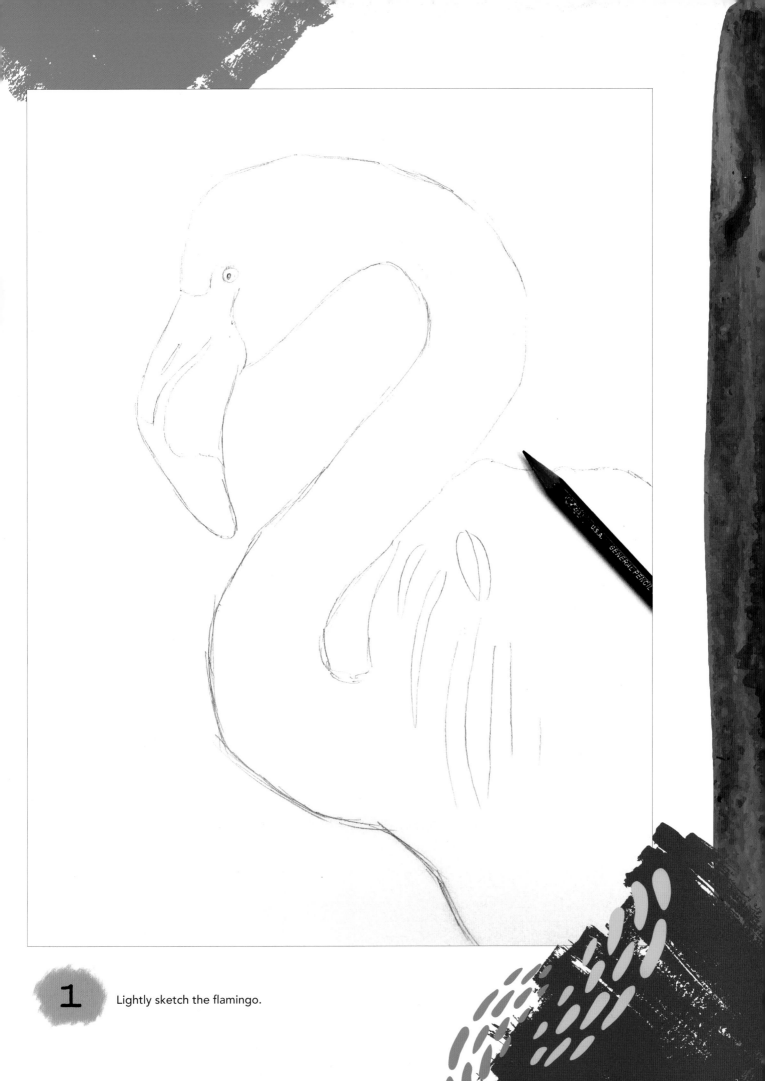

1 Lightly sketch the flamingo.

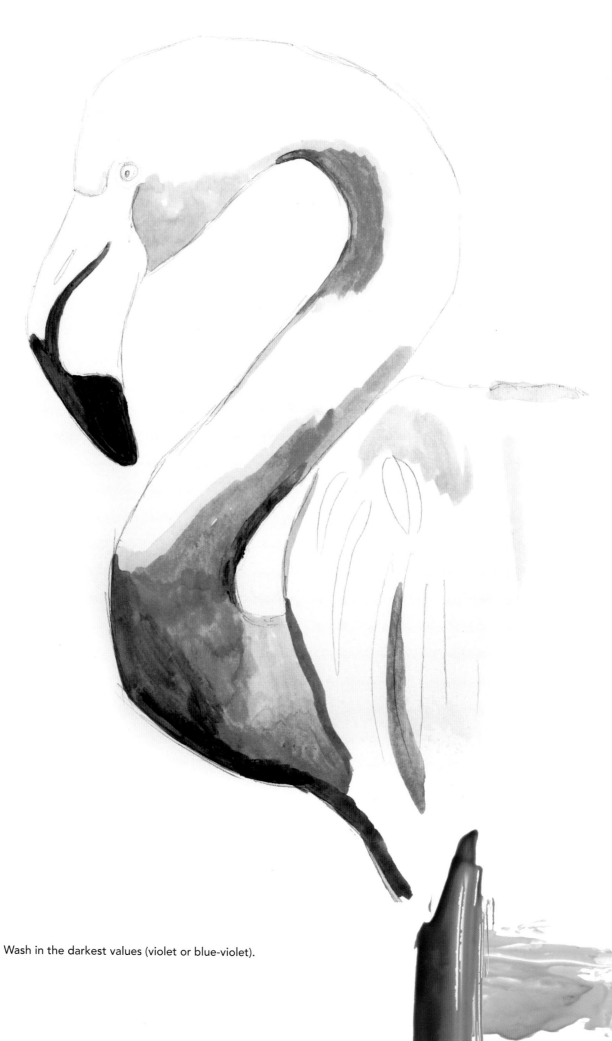

2

Wash in the darkest values (violet or blue-violet).

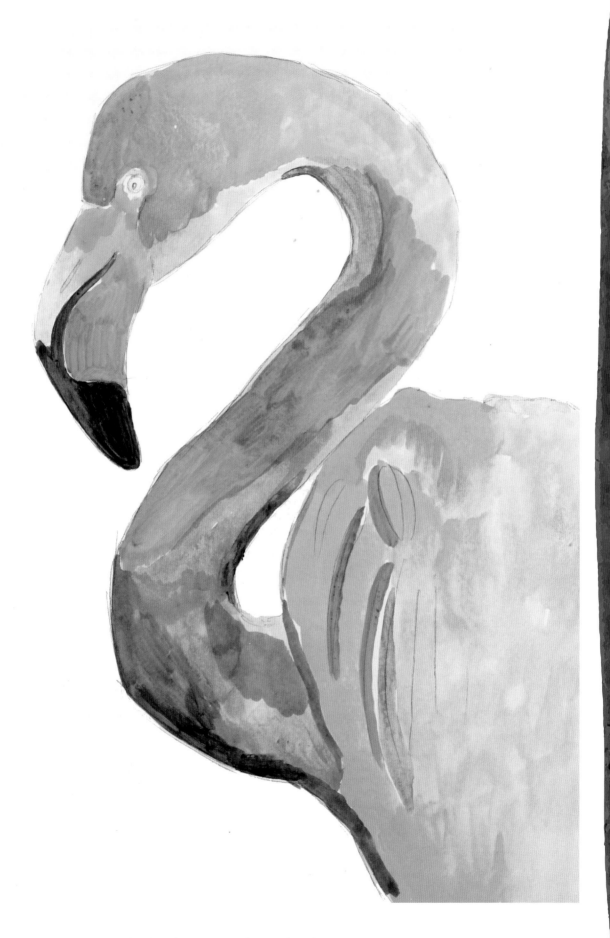

 3 Wash in the medium and light values. Choose from red, red-orange, orange, green, blue-green, or blue.

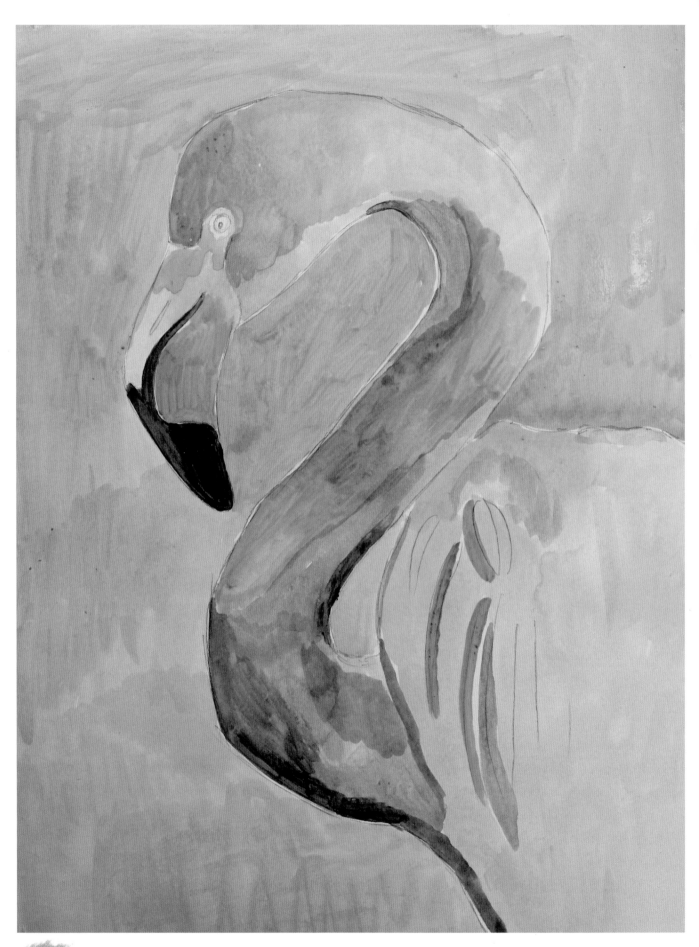

 4 Add the background wash.

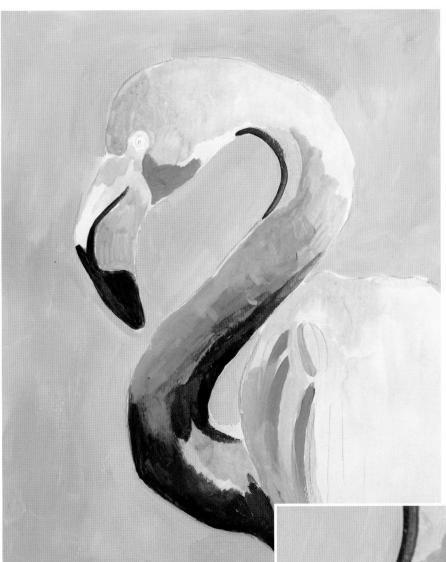

Start blocking in color. I like to begin with the background and then move to the foreground, working with my darker values first.

Let those brushstrokes show! I've never seen a perfectly smooth flamingo, have you? Embrace being expressive and free, and let go of that need for perfection.

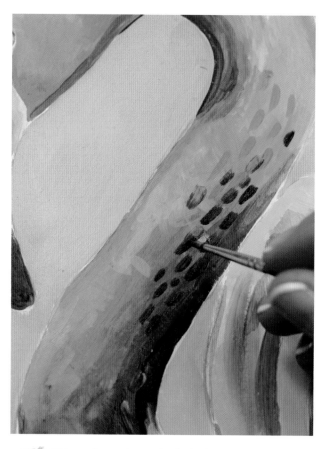

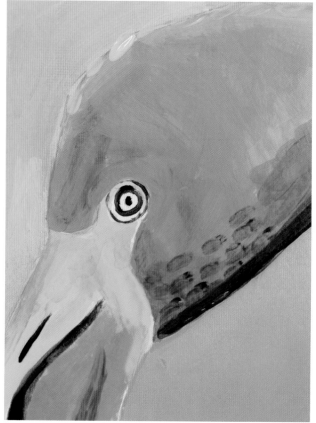

7 Sometimes, the little things make a painting stand out. By using small brushstrokes that mimic the direction of a flamingo's feathers, I'm able to add that extra "oomph" to my painting.

8 Save the details, like the flamingo's eye and the lightest highlights, until the end.

9 Don't forget about the background! It doesn't have to be a solid color. I add darker orange brushstrokes that mimic the lines of the flamingo to create a sense of movement.

10 Now step back and critique yourself! Do you have a full range of values, from your darkest dark (violet) to your lightest light (yellow)? Does your foreground stand out against your background? These are good questions to ask yourself when you are at the final stage of any piece.

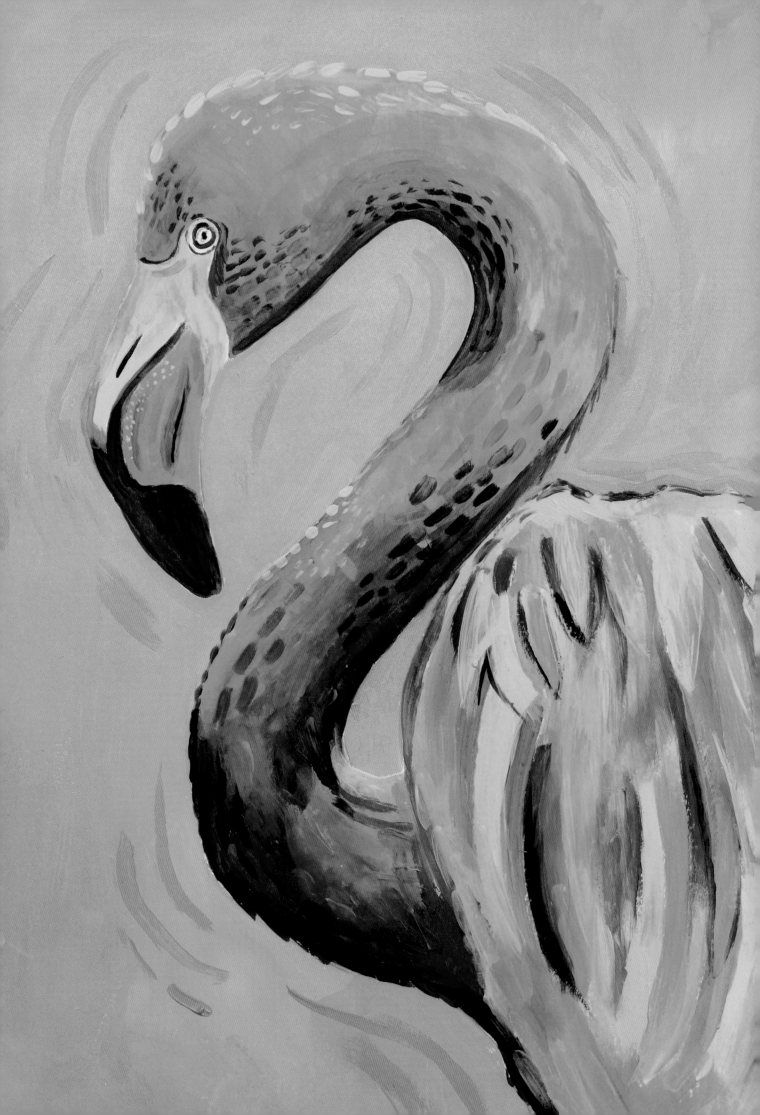

Pointillistic Panda

With the pointillism technique, small dots of various colors are placed right next to each other so that they appear to blend. For instance, red and yellow dots will blend and look orange. Up close, you notice the individual dots, but the farther back you stand, the more the colors will appear to mix.

This also applies to value. For example, if you layer light-colored dots on top or next to black dots, the area will appear gray.

Let's learn about this art technique by painting a panda. This time, I want you to forget about planning a color scheme. Pointillism offers a fun, spontaneous way to express yourself using color, so skip the swatches and jump right into your piece!

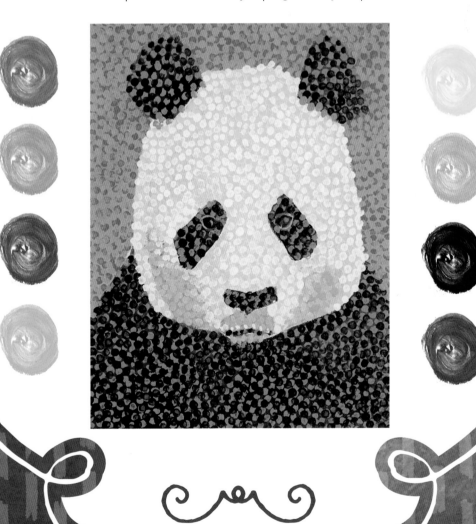

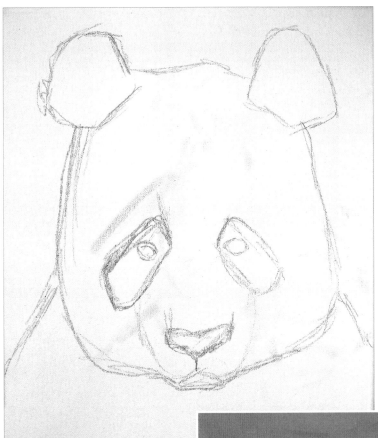

 1

Sketch your panda.

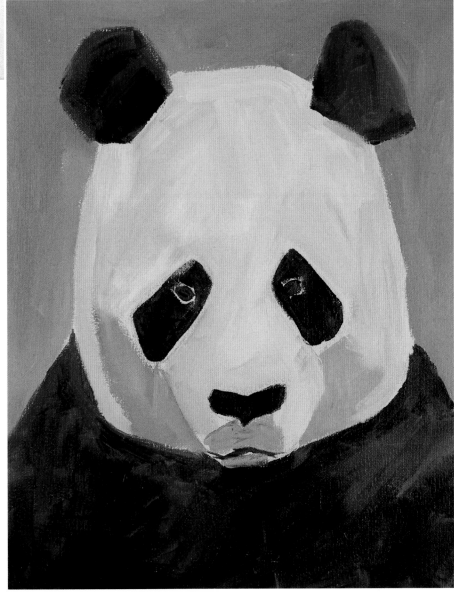

2

Add a wash or an underpainting.

I use a vibrant violet for my underpainting, but you should use any color you like!

3

Now, block in areas of color using the pointillism technique. Be patient: This process takes time, as you'll have to layer your dots a couple of times.

I begin in the background and apply pink dots over the mid-range violet.

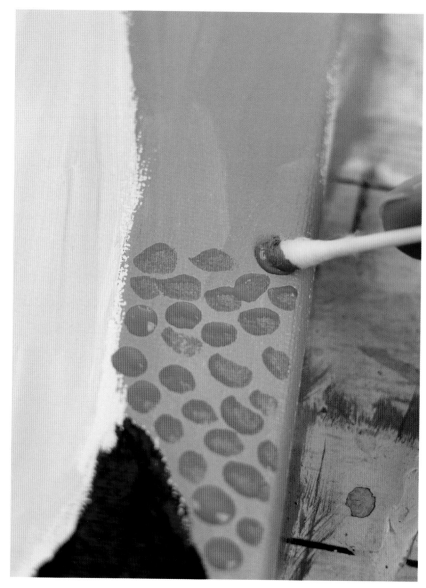

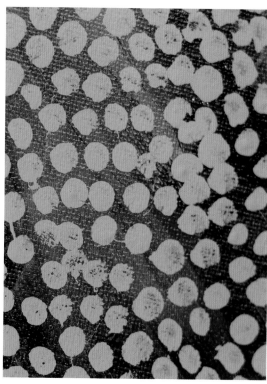

4

Next, I move to the darkest values of the panda, lightening them up a bit with a lighter blue-violet.

Your dots don't need to be perfectly round. I use a cotton swab to create my dots, but the end of a pencil or tip of a small paintbrush.

5

Then I add the lightest value using a bright yellow.

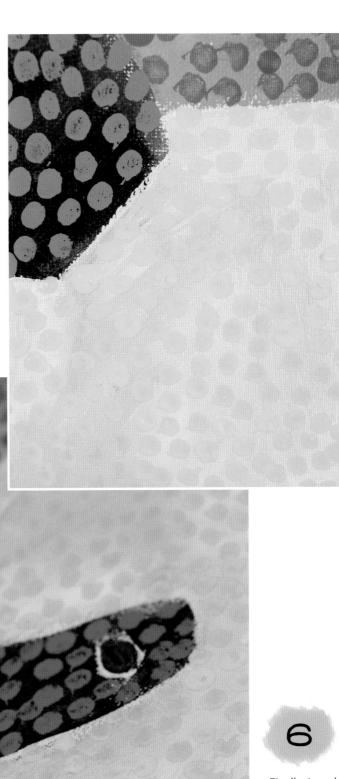

6

Finally, I apply midtones with coral.

 7 Now, add a second layer of dots.

Once again, I start in the background and use coral to layer on top of the pink dots. Then I apply navy blue over the lighter blue-violet in the darkest values. This darkens my piece, but the other violets showing through keep it from looking too dark.

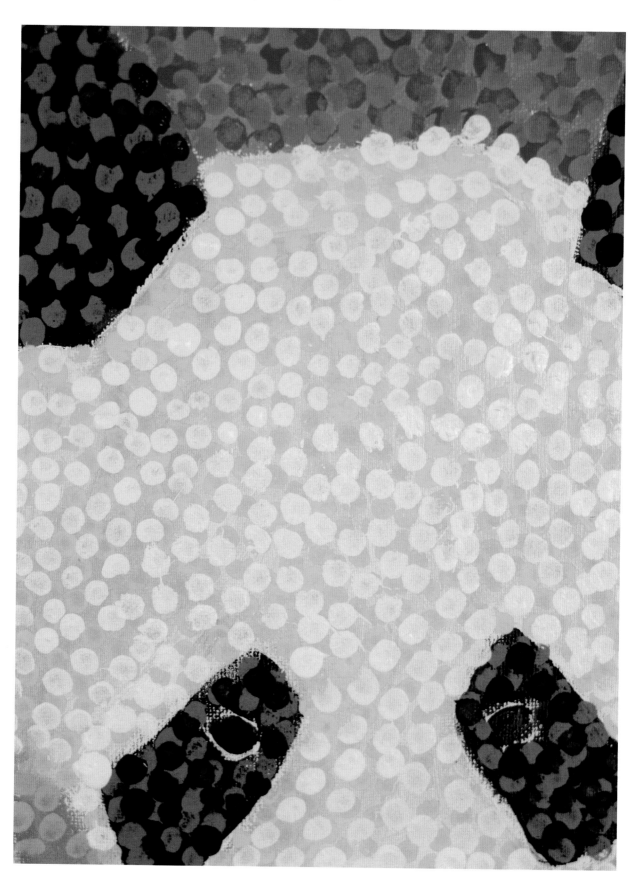

8

I add a layer of white dots on top of the yellow to lighten the panda's face, as well as pink in the midrange areas.

Don't be afraid to use a brush here and there. It's not cheating when there are no rules!

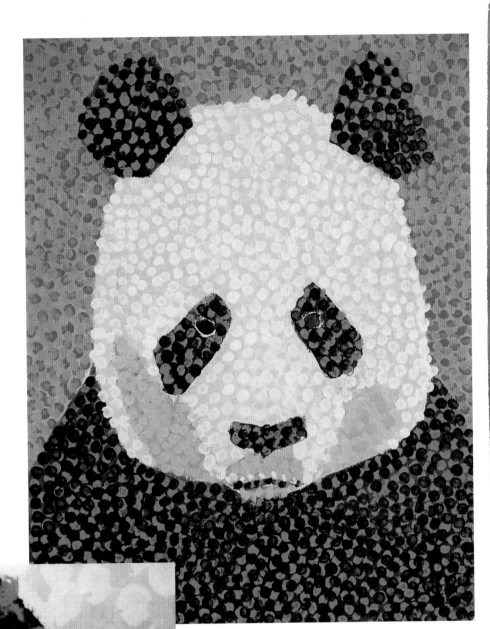

9

Setting aside the cotton swab for a minute, grab a paintbrush and add the details of the panda's eyes.

 10 Lastly, use a cotton swab once again to add subtle shading to the panda's face. Also, blend some of the shaded areas.

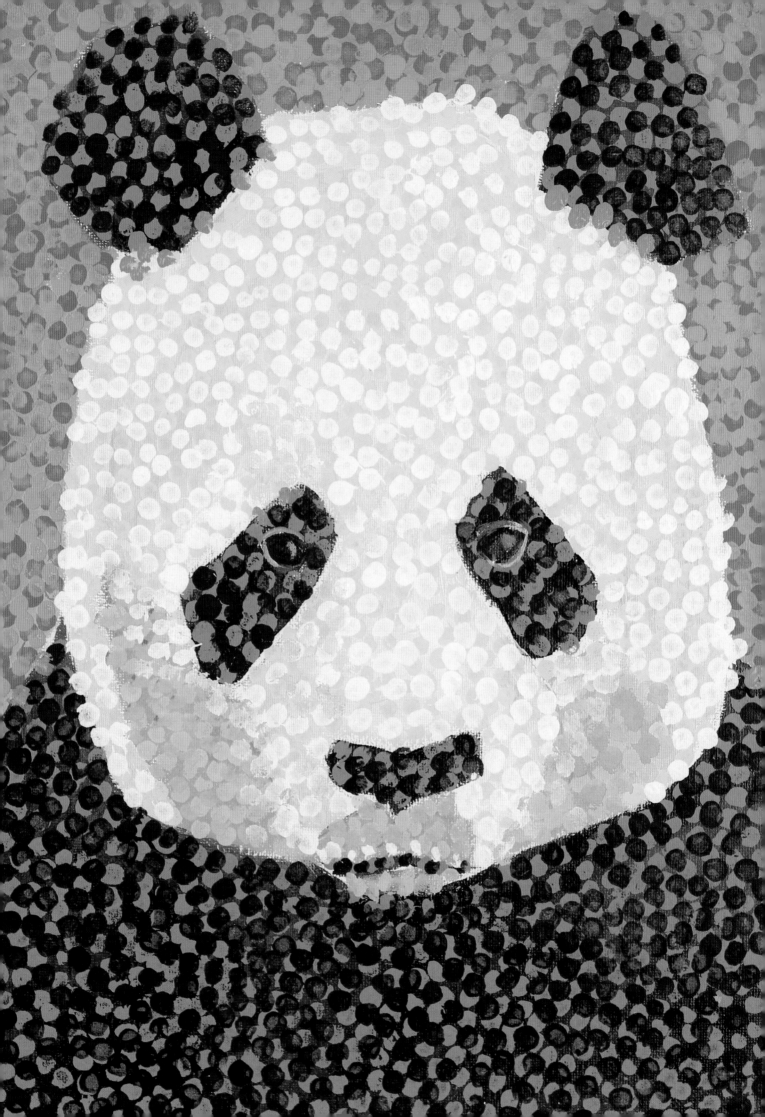

Mixed-Media Fox

For this project, I want you to gather as many sheets of scrap paper as you can. Notebook paper, patterned paper, lace paper, tissue paper, old book pages, maps, and gift wrap can all find their way into your mixed-media fox.

What is mixed media, you ask? Well, it's just what it sounds like: using a few supplies mixed together to create a finished piece. In this piece, we'll use acrylic and collage to create an extra-funky fox!

Let's get started!

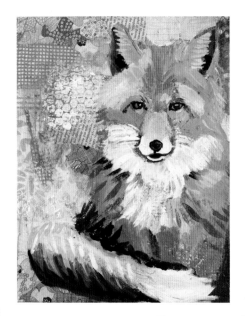
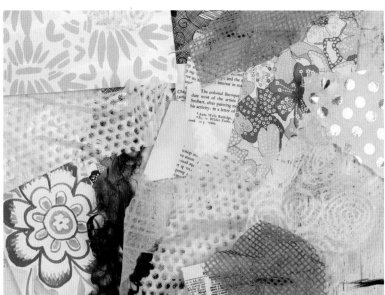

Lace paper can be tough to find. Search the internet for Japanese lace papers, and you'll have a whole plethora of options at your fingertips!

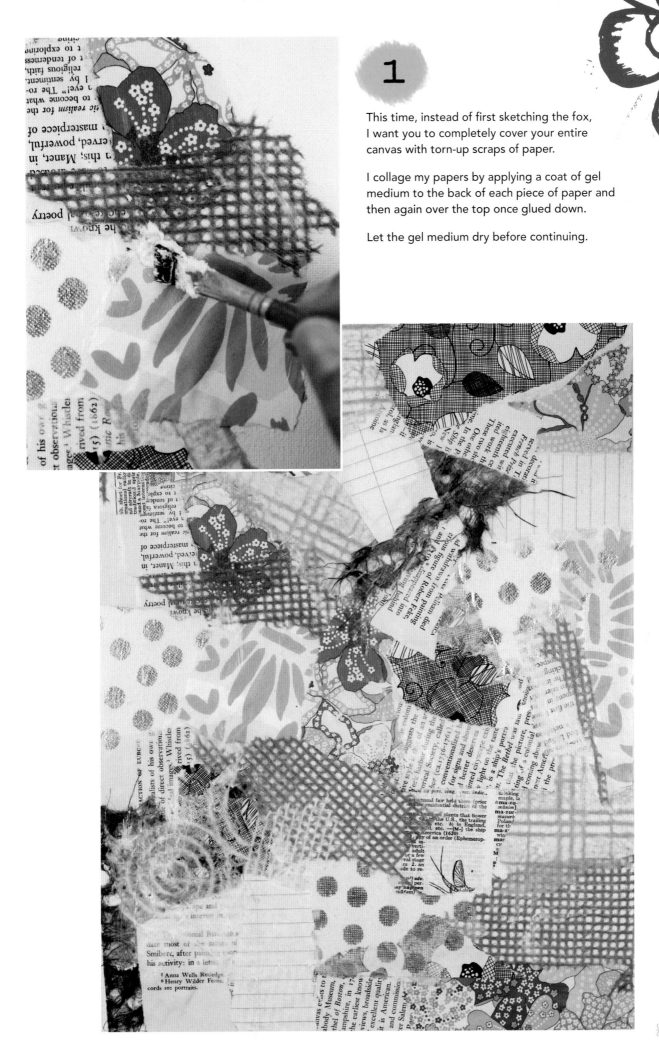

1

This time, instead of first sketching the fox, I want you to completely cover your entire canvas with torn-up scraps of paper.

I collage my papers by applying a coat of gel medium to the back of each piece of paper and then again over the top once glued down.

Let the gel medium dry before continuing.

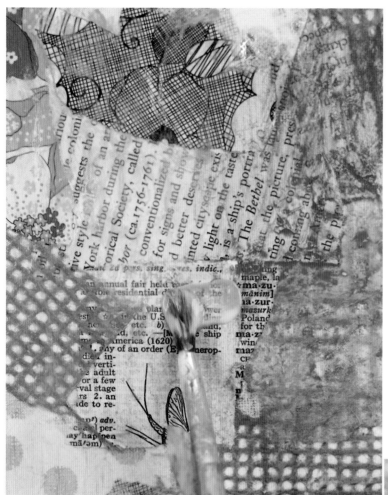

2

Now, slap on different colors of paint in some areas or all over the piece. Don't overthink this step; follow your instincts!

Mix the paint with fluid matte medium to thin it out and let the papers show through. I paint my entire canvas with transparent blues and violets.

3

I add more texture and interest by painting onto bubble wrap and then stamping the color onto the canvas. This creates a messy polka dot pattern, which adds to the fun!

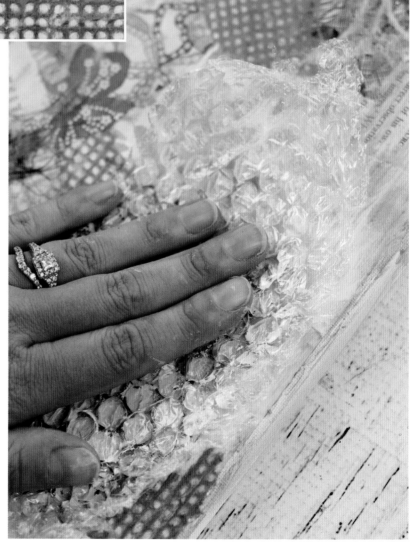

4 Next, freehand sketch your fox using a dark pencil or a white paint pen. It's a little tricky drawing on top of gel medium, but using a softer lead (such as a 4B or 6B pencil) will make things easier if your surface is light. If it's dark, I recommend using a white paint pen for your sketch.

Don't worry about stray pencil or pen marks. It's difficult to erase over gel medium, but this piece is going to have a lot of layers, so you can always cover up any mistakes!

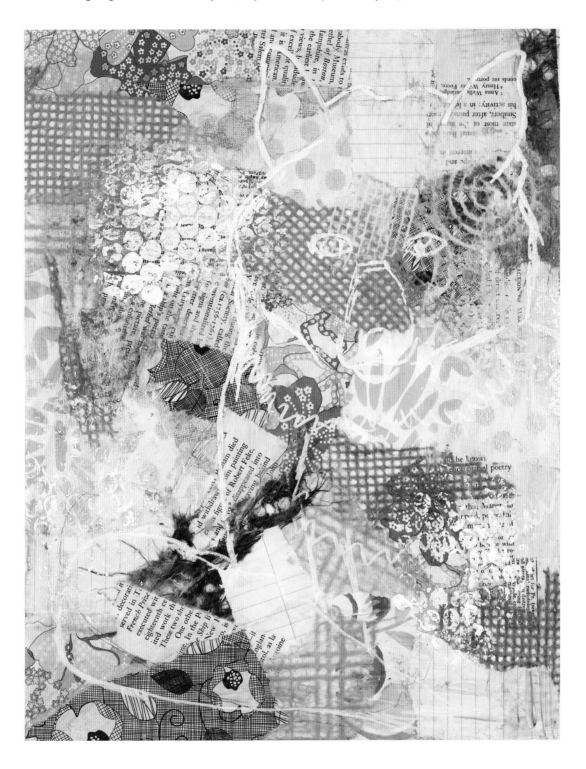

This is the time to throw out any freehand-drawing fears you may have! This piece should look expressive and free, so don't get hung up on creating the perfect sketch.

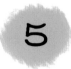

5 Now, let's work on the fox. Begin by blocking in large areas of color.

I use oranges, pinks, and red-violets for my fox so that these warm colors will contrast with the cooler background. I let the collaged papers show through in a few areas.

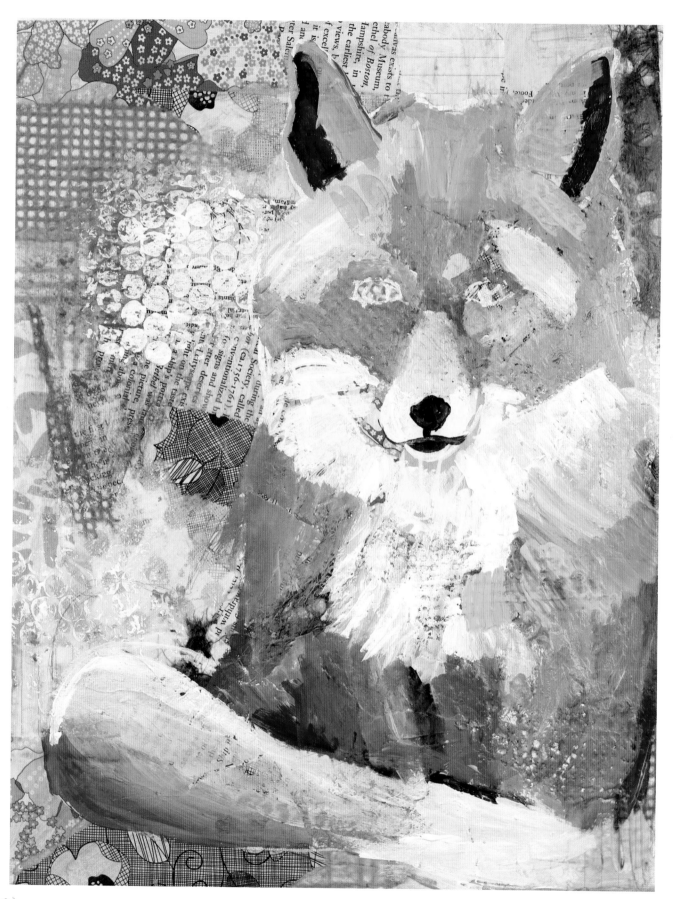

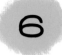

6

Begin building up details in the fox.

I focus on the fox's face, leaving its body and fur looser and more expressive.

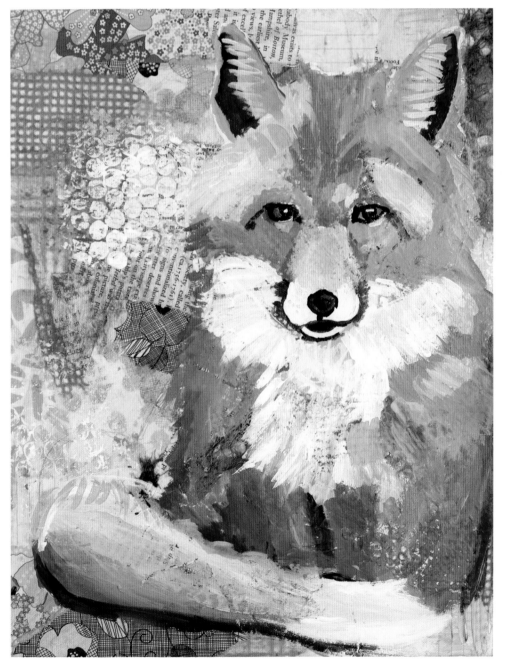

By now, you should have a good understanding of how you like to paint. Once you're painting the animal in your piece, work the way that you like.

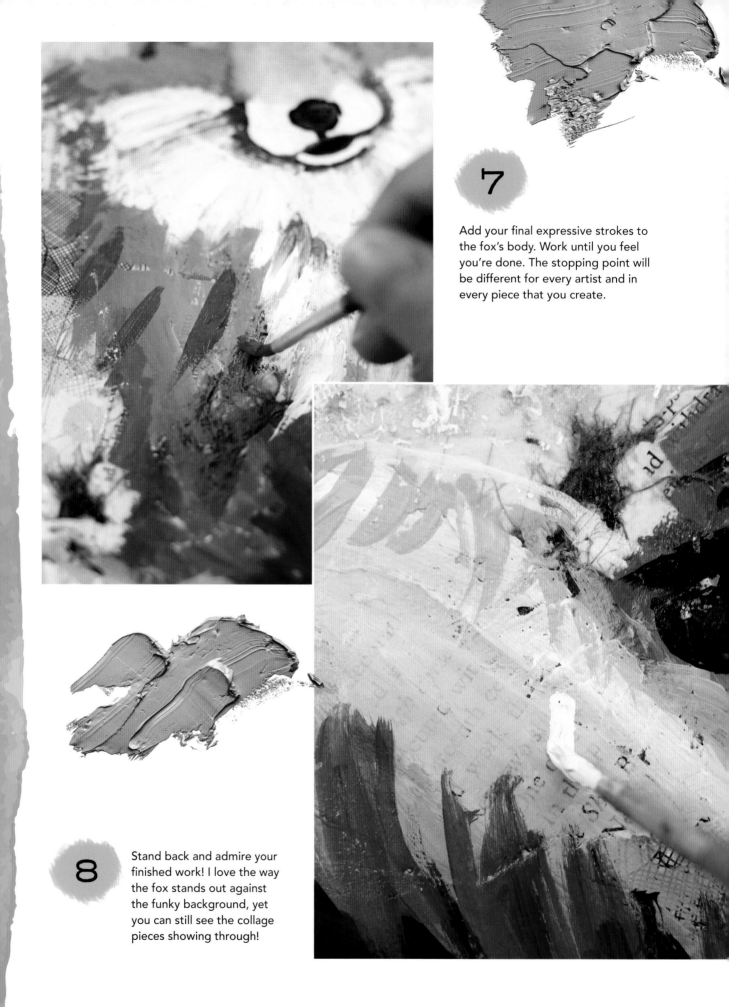

7

Add your final expressive strokes to the fox's body. Work until you feel you're done. The stopping point will be different for every artist and in every piece that you create.

8

Stand back and admire your finished work! I love the way the fox stands out against the funky background, yet you can still see the collage pieces showing through!

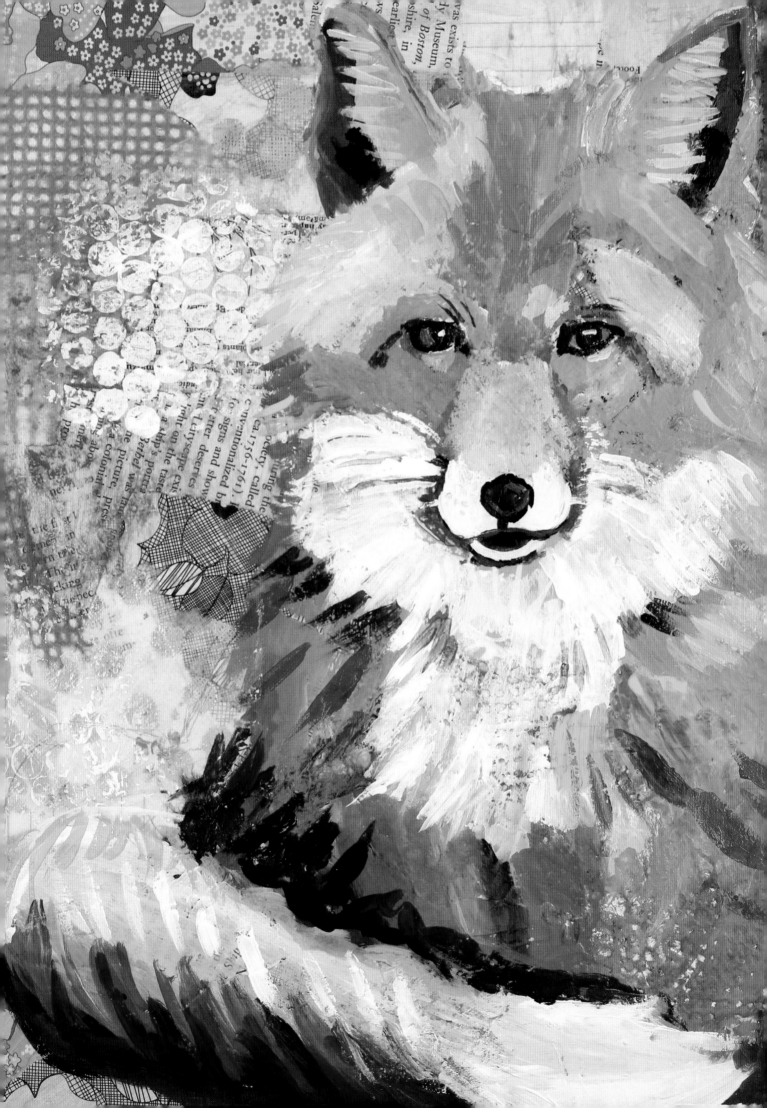

Dimensional Pug

Our final project features a cute, wrinkly-faced Pug. Here, you will create a piece filled with dimension and, of course, bold color choices.

To add dimension to this piece, you'll use the impasto technique with modeling paste, so gather your supplies and images, and jump in!

Once again, I follow my instincts and create a color palette as I work. However, if you like creating swatches and referencing those before getting started, go ahead and paint them. By now, you know how you like to work!

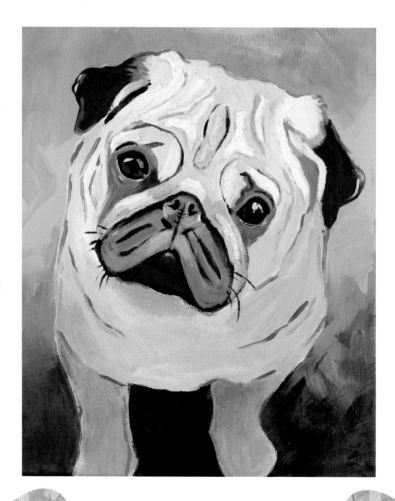

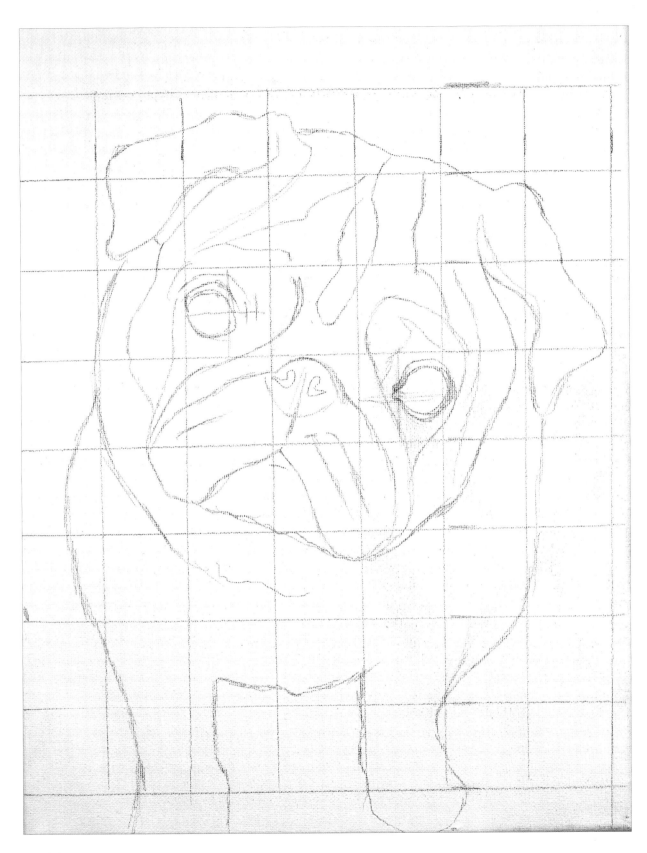

1

Sketch in your Pug.

I want to focus on the dog's face and make its features accurate, so I use the grid method (page 23) to complete my sketch.

2 Create an underpainting.

I choose to use blues and blue-greens for my underpainting because I want to add warmer colors to the dog's body.

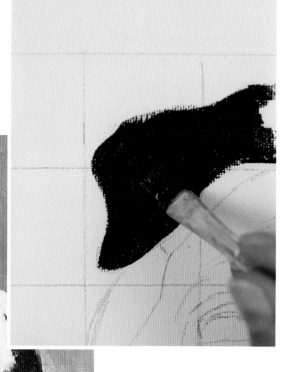

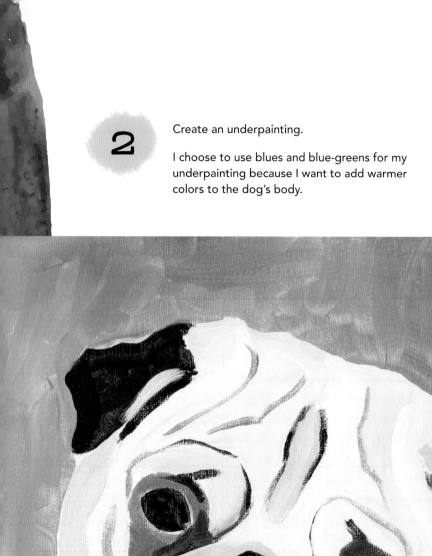

Featuring opposing colors in a piece adds depth.

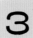

3

Next, use an older paintbrush to apply modeling paste in the areas of the Pug that you want to emphasize.

I apply a layer of modeling paste to the dog's facial folds, ensuring that they stand out and appear to recede. Once the first layer dries, I add a second one to create even more depth in my piece.

Brushing on the modeling paste gives it texture. If you prefer a smoother surface, use sandpaper to very lightly remove the texture from the completely dry modeling paste.

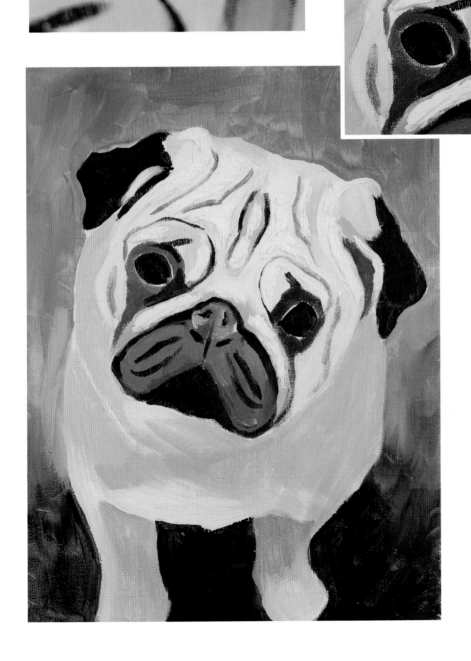

Modeling paste is matte and will dry white. Mixing it with paint will lighten the color of the paint, so keep that in mind. Here, I chose to apply the modeling paste without mixing it with paint.

 4 While the modeling paste dries, add a second coat of paint to your background. You can use the same color as the underpainting, or try something different.

I paint a fun, expressive background using a blue-green hue.

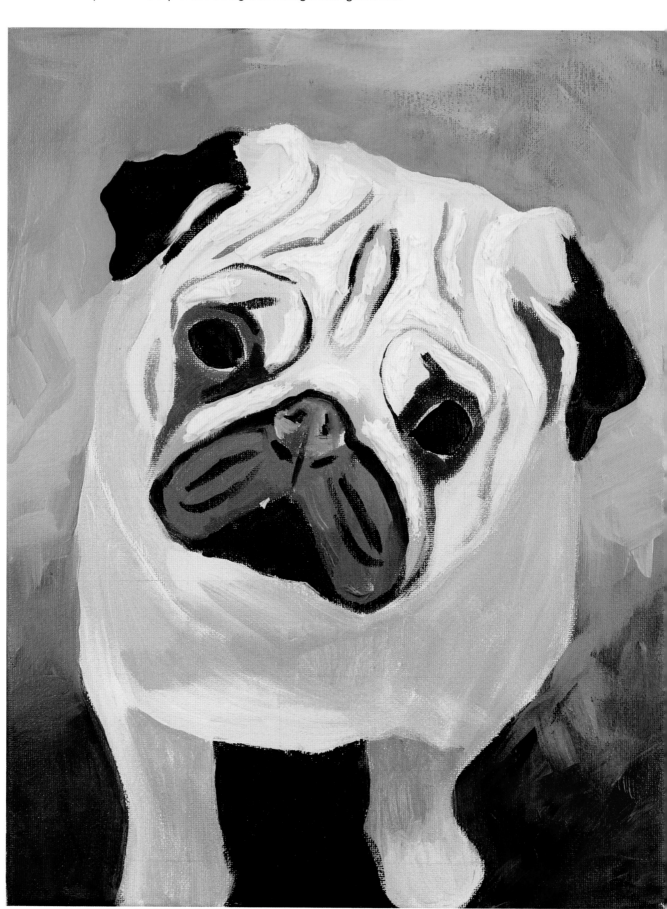

5

Once the modeling paste is completely dry, add a second coat of paint to your Pug.

I use bright, warm colors for the dog to make it stand out against the cooler underpainting.

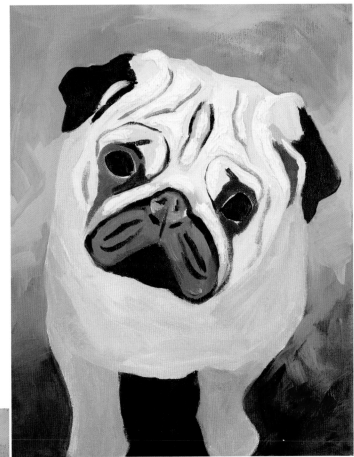

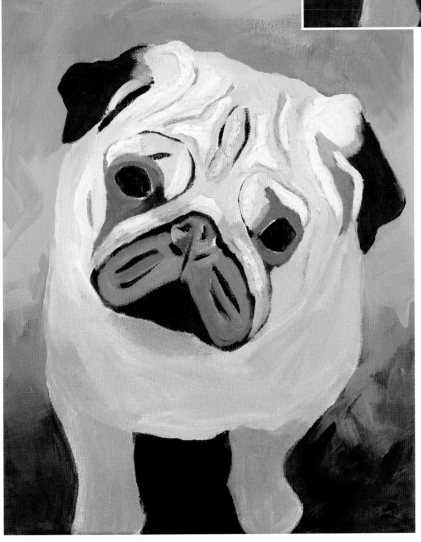

6

Paint over the modeling paste. To give the Pug's wrinkles even more depth and dimension, feature your lightest color at the highest point of the modeling paste, and subtly fade it out as you move down your canvas.

7

Add details to the dog's face and wrinkles.

I focus on the eyes, nose, and wrinkles and leave most of the body more unfinished.

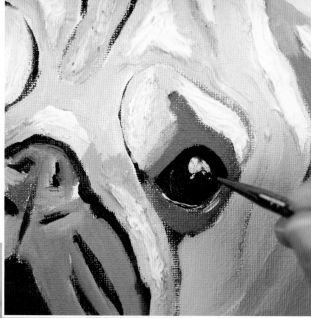

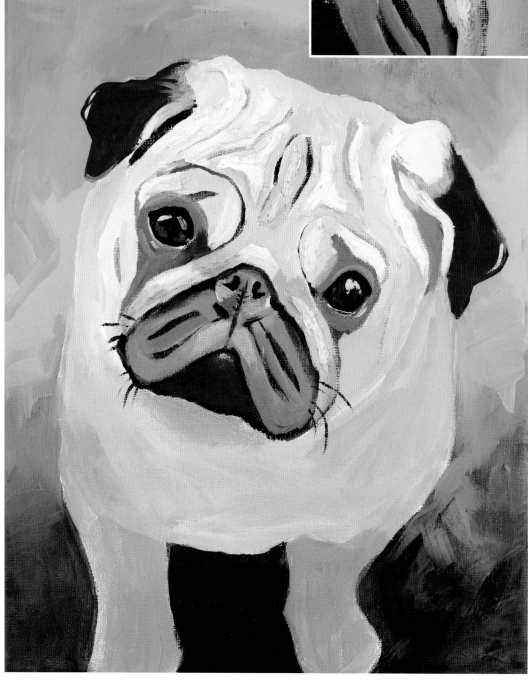

8

Add your final touches!

I add expressive lines throughout the Pug's contours before deciding he is complete. The dimension in this piece is even more visible in person than in a photograph, and I love how it turned out!

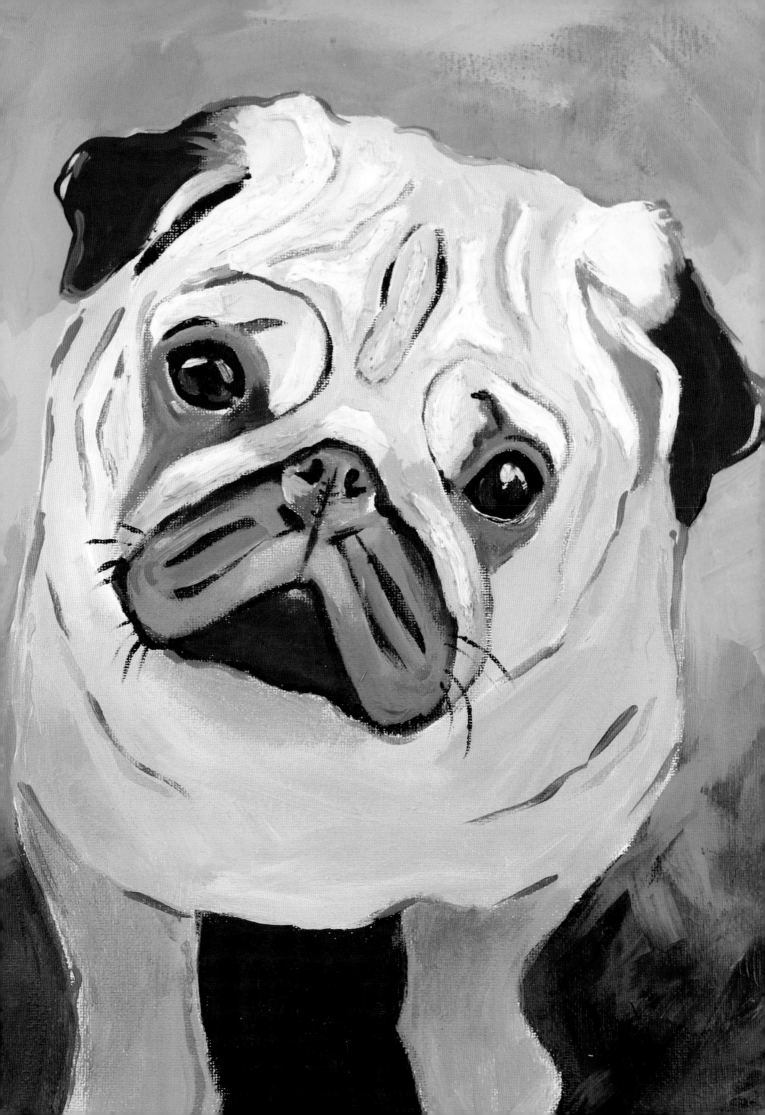

About the Artist

Megan Wells is an artist, author, and instructor living in Fort Lauderdale, Florida. She's been passionate about art from an early age and earned a bachelor's degree in fine art in 2005. After six years teaching high-school art, Megan's hand-lettering and illustration studio, Makewells, took off, and she was able to step out of the classroom and into the studio full time. Her work has been licensed and commissioned by book publishers, magazines, and major retailers.

When not in the studio, Megan can be found at the beach, playing tennis with her husband, or making green smoothies.

To learn more about Megan and her work, visit www.makewells.com and follow her on Instagram @makewells

Photo credit: Michelle VanTine